HOCKEY IN
NEW HAVEN

On the front cover: Elgin McCann of the New Haven Blades is seen here in 1969. (Courtesy of Andy Paris.)

On the back cover: The New Haven Knights played against the Mohawk Valley Prowlers at the New Haven Veterans Memorial Coliseum in 2000. (Courtesy of Guy Guglielmi.)

Cover background: Seen here is the New Haven Eagles 1941–1942 team photograph. (Courtesy of the New Haven Traveling Hockey Museum archives.)

HOCKEY IN NEW HAVEN

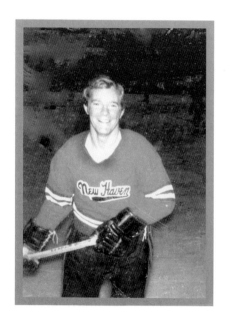

Heather Bernardi and Kevin Tennyson

ARCADIA
PUBLISHING

Published by Arcadia Publishing
Charleston SC, Chicago IL, Portsmouth NH, San Francisco CA

Printed in the United States of America

Library of Congress Catalog Card Number: 2007924162

For all general information contact Arcadia Publishing at:
Telephone 843-853-2070
Fax 843-853-0044
E-mail sales@arcadiapublishing.com
For customer service and orders:
Toll-Free 1-888-313-2665

Visit us on the Internet at www.arcadiapublishing.com

To my father, George Tennyson, who brought me to my first New Haven

Nighthawks game at the coliseum all those years ago.

—Kevin Tennyson

To my mother and my friend, Linda Mislow, who has always been there

to support and encourage me throughout my entire life.

—Heather Bernardi

CONTENTS

ACKNOWLEDGMENTS

The images in this book have been provided courtesy of the New Haven Traveling Hockey Museum archives. Many of these original photographs, which were donated to the museum by various persons, do not have any credits or markings on them. The coauthors, to the best of their abilities, wish to thank and credit the many photographers whose fine work may appear in this book and without such images this book would not be possible. The photographers are as follows, including but not limited to: Jennifer Alfieri, Ralph Andreozzi, Sharon–Lee Augur, Dave Baribeault, Tom Bierne, Paula Bronstein, Drew Carrano, Dennis Cartolano, Chieppo family archives, Robert C. Child III, Tim Danton, Mike Davenport, Tom DeRosa, Donald Donofrio III, Pamela Dunlop, Bernard English, Lorenzo Evans, Steven Feldman, Gary Ferdinand, Charles Fields, Bruce Gorlick, Wayne Greene, Guy Guglielmi, Hartford Whalers Hockey Club, Kirby Kennedy, Ken Laffel, Walt Mann, Gary Mattei, Phil McDermott, Ron McDermott, Jim Meehan, Richard Mei, Ray Morris, John R. Musco, Chris Neely, New Haven Professional Hockey Teams inclusive, *New Haven Journal–Courier* photographers, *New Haven Register* photographers, *New Haven Times Service* photographers, Phil Noel, Matthew Opie, Andy Paris, Susan Paris, Andy Pippa, Rob Podoloff, Kenneth Randolph, Diane Rosenberg, Dr. Zelly D. Ross, Paul Sullivan, Angelo Squeglia, Kevin Tennyson, E. Vanacore, and John M. Vollaro.

The statistics in this book were obtained from *Total Hockey: The Official Encyclopedia of the National Hockey League* (second edition), Ralph Slate's hockey database (www.hockeydb.com), American Hockey League media guides (1972–1999), and various New Haven professional hockey team publications and official score sheets (1926–2002), Danbury Trashers publications (2004–2006), and *New Haven Journal–Courier* and *New Haven Register* articles (1926–2002).

All New Haven National Hockey League affiliations cited in this book are official working agreements between New Haven and National Hockey League clubs. Gary Ferdinand assisted Kevin Tennyson in reviewing this book for historical accuracy. Special thanks to Jennifer Vollaro for help with photographs.

I wish to thank my two children Frank and Joclyn for all their help and encouragement. I would also like to thank my husband, Mike, for all his love and encouragement.

We would also like to thank Arcadia Publishing for giving us this wonderful opportunity.

—Heather Bernardi

INTRODUCTION

Professional hockey in New Haven spans 76 years, from 1926 to 2002. The New Haven Eagles were the Elm City's first team, competing in the newly formed Canadian–American Hockey League in 1926–1927. The birds played their home games at the newly opened New Haven Arena. The Can–Am League amalgamated with the International Hockey League to form the International American Hockey League for the 1936–1937 season. For the 1940–1941 season, International was dropped from the name of the International American League and the league was called the American Hockey League (AHL). Between 1926 and 1943 and also 1945 and 1946, the Eagles played 17 seasons while withdrawing once from the AHL in 1942, and also having the franchise moved to Brooklyn, New York, while a member of the Eastern Hockey League (EHL) in 1943.

The New York Rangers placed their top farm team in New Haven, starting in 1946–1947 as the New Haven Ramblers of the AHL, and played four seasons in the Elm City, their final season being 1949–1950. After the New York-owned-and-operated Ramblers pulled out, the Arena Company placed the New Haven Eagles back into the AHL for the 1950–1951 season but was forced to withdraw the team from the league on December 10, 1950.

The Arena Company, in a move aimed at cutting operating costs, decided to place a team in the EHL in 1951–1952, and thus the New Haven Tomahawks hit the New Haven Arena ice. The following season (1952–1953) the team name was changed to the New Haven Nutmegs. The EHL did not operate in 1953–1954.

After reorganizing, the EHL returned for the 1954–1955 campaign, and so did the Elm City as the New Haven Blades, under the new ownership of Harry Glynne and Jerry DeLisle, ushered in the golden era of New Haven hockey. The Blades played 18 seasons in the EHL from 1954 to 1972, which included the Blades winning the Elm City's only professional hockey championship when New Haven won the Boardwalk Trophy in 1955–1956. The Blades appeared in the EHL finals three other times but were unable to win a second championship before leaving for West Springfield, Massachusetts, after the 1971–1972 season.

The 1972–1973 season saw the New Haven Arena close and marked the opening of the brand-new, state-of-the-art, 8,871-seat New Haven Veterans Memorial Coliseum, and with it the return of the AHL to the Elm City, after a 21-year absence. The high-flying New Haven Nighthawks would spend the next 20 years (1972–1992) entertaining Greater New Haven area hockey fans, with their rosters full of future and past NHL players. While the Nighthawks fell short of winning the Calder Cup each of the four times they advanced to the AHL finals (1974–1975, 1977–1978, 1978–1979, and 1988–1989), the memories they gave to their adoring fans will last forever. Jack McColl, Joel Schiavone, Roy Mlakar, Jim Perillo, Pat Hickey, and countless others were instrumental in keeping the Nighthawks flying at the New Haven Veterans Memorial Coliseum.

The coliseum was also home to the New Haven Senators (AHL) in 1992–1993, the Connecticut Coasters (Roller Hockey International) in 1993, the Beast of New Haven (AHL) from 1997 to

1999, and finally the New Haven Knights (United Hockey League) from 2000 to 2002. The coliseum was closed on September 1, 2002, and was imploded on January 20, 2007.

This book is simply a look back at some of the many hockey players who plied their craft in New Haven, within the space limitations herein.

EAGLES TAKE FLIGHT

EAGLES PROGRAM, 1927–1928. The Canadian-American Hockey League (CAHL) was formed on Thanksgiving Day, 1926. The New Haven Eagles competed for 10 seasons in the CAHL, winning one division title and advancing to the Fontaine Cup Finals once (1926–1927). In 1936–1937, the CAHL and the International American Hockey League (IAHL) amalgamated to form the American Hockey League (AHL). The Eagles (AHL) folded on January 18, 1943. The Eagles joined the Eastern Hockey League (EHL) in 1943–1944, however, the franchise was moved to Brooklyn, New York, three weeks into the season. Eddie Shore operated the 1945–1946 New Haven Eagles in the AHL. The Arena Company placed the New Haven Eagles in the AHL for 1950–1951, but the team folded midseason.

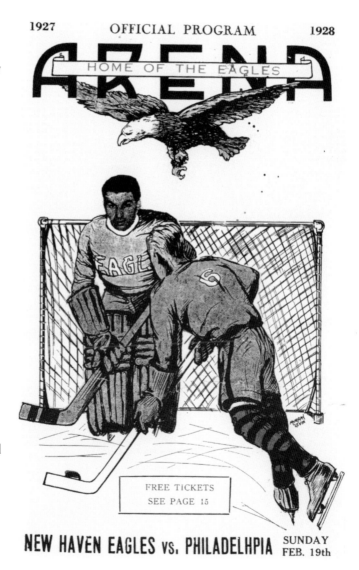

1927 OFFICIAL PROGRAM 1928

ARENA

HOME OF THE EAGLES

EAGL

FREE TICKETS
SEE PAGE 15

NEW HAVEN EAGLES vs. PHILADELHPIA SUNDAY FEB. 19th

NORM SHAY. Defenseman Norm Shay played two seasons for the New Haven Eagles, 1926–1927 and 1929–1930, scoring 15 points, with 10 goals in 62 games. Shay played in the National Hockey League (NHL) for the Boston Bruins and the Toronto St. Pats. He also played in the United States Amateur Hockey Association (USAHA) for the New Haven Westminsters in 1922–1923 and the New Haven Bears the following season. Shay also owned a sporting goods store in New Haven for many years.

BABE DYE. Hockey Hall of Fame right wing Babe Dye played 271 games in the NHL. He scored 246 points on 202 goals. He played in the NHL for Toronto, Hamilton, Chicago, and the New York Americans. On November 13, 1929, he was traded from New York to the New Haven Eagles for George Massecar. Dye played 34 games with the Eagles, scoring 11 goals for 15 points in 34 games.

ALBERT HUGHES. In 1929–1930, Albert Hughes had 41 points and 22 goals in 40 games with the Eagles. The center played parts of three seasons (1928–1932) with New Haven and accumulated 64 points and 36 goals in 103 games. He also played two seasons (1930–1932) in the NHL with the New York Americans and had 14 points, 8 assists, and 22 penalty minutes (PIM) in 60 games.

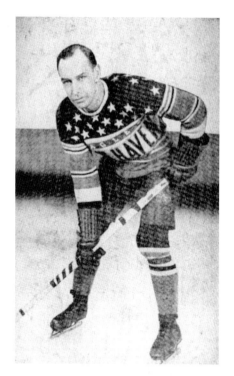

YANK BOYD, ARMAND MONDOU, AND TONY HEMMERLING. This was one of the top forward lines for the New Haven Eagles in the 1930s. Center Yank Boyd was a crafty individual who played nearly 100 games in the NHL. Armand Mondou, the winger, was a veteran of almost 400 NHL games. The other wing, Tony Hemmerling, an all-star for the Eagles in 1939–1940, tallied 128 points on 57 goals in 185 games.

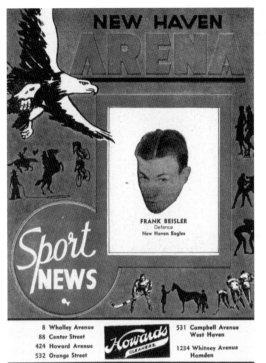

FRANK BEISLER. The first Connecticut-born player to skate in the NHL, Frank Beisler did this when he dressed for the New York Americans during the 1936–1937 season. He played 157 games for the New Haven Eagles (1934–1938), totaling 20 points and 141 PIM. Beisler was an AHL All-Star in 1941, 1942, and 1943. In 1945, he coached the Buffalo Bisons of the AHL to the Calder Cup championship.

GUS FORSLUND. This highly skilled skater from Umea, Sweden, played right wing for the 1935–1936 New Haven Eagles. Forslund netted 16 goals and added 17 assists for 33 points in 48 games. He appeared in 48 games with the Ottawa Senators of the NHL in 1932–1933. Forslund also made stops in Syracuse and Philadelphia.

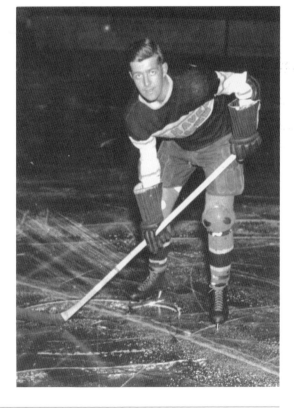

EAGLES TAKE FLIGHT

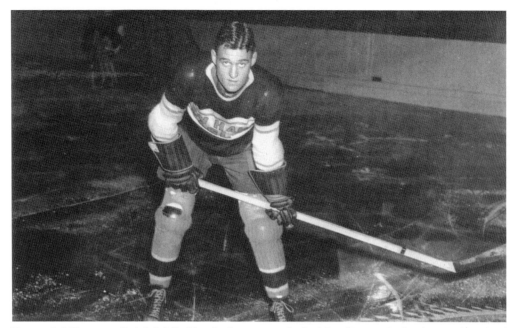

RALPH MCFADDEN. Ralph McFadden had a stint with the New Haven Eagles during their final season in the CAHL. The crafty left-winger's forte was as a defensive specialist, and he was regularly assigned to shadow the opposition's top scorer. McFadden assumed a similar checking role in his other professional stops in Wichita, Philadelphia, and St. Paul.

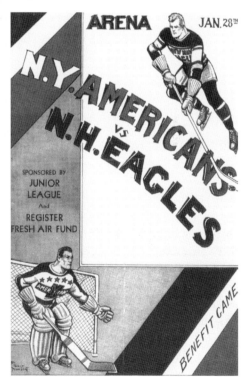

BENEFIT GAME. On January 28, 1937, the New Haven Eagles played their parent team, the New York Americans of the NHL, in a benefit game for the New Haven Register Fresh Air Fund at the New Haven Arena. The New Haven Register Fresh Air Fund was established in 1905 by the newspaper's owners at the time, the Jackson family. The fund is one of the area's oldest, most-respected charities.

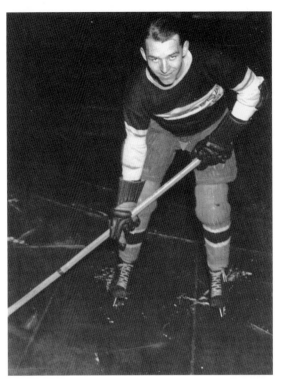

OSSIE ASMUNDSON. Right-winger Ossie Asmundson played with the New Haven Eagles for two seasons (1935–1937) and garnered 16 goals, 34 assists, 50 points and 58 PIM. He played a total of 16 seasons in the professional ranks, including 111 NHL games in which he totaled 34 points, including 11 goals.

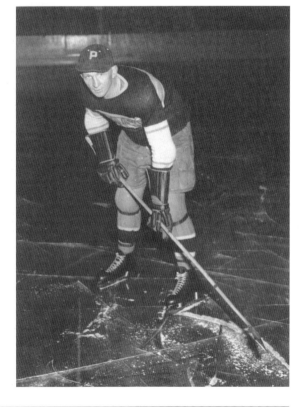

JOE MCGOLDRICK. Rugged defenseman Joe McGoldrick played 1931–1932 and 1935–1936 for the New Haven Eagles. He scored 31 points for the Eagles and added 66 PIM. He also played for the Portland Buckaroos, Boston Cubs, Philadelphia Arrows, Springfield Indians, Providence Reds, Hershey Bears, and Calgary Stampeders during his distinguished playing career.

"BULLET JOE" SIMPSON. Hockey Hall of Famer "Bullet Joe" Simpson coached the New Haven Eagles in 1931–1932. He is pictured in the center of the game program shown here. Bullet Joe also played six seasons as a defenseman in the NHL with the New York Americans racking up 156 PIM along with 40 points in 228 games.

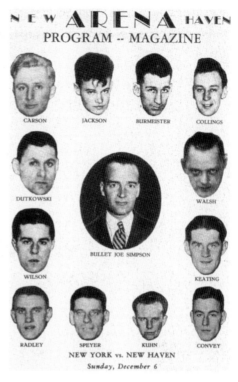

EARLY NEW HAVEN ARENA. The newly opened New Haven Arena was the only facility of its kind between Boston and New York during this time period. The New Haven Eagles called the arena home for 17 full and 3 partial seasons. Seating just less than 4,000, the building afforded fans an up close and personal look at their heroes on the ice.

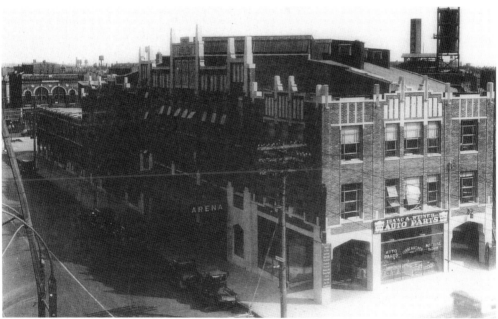

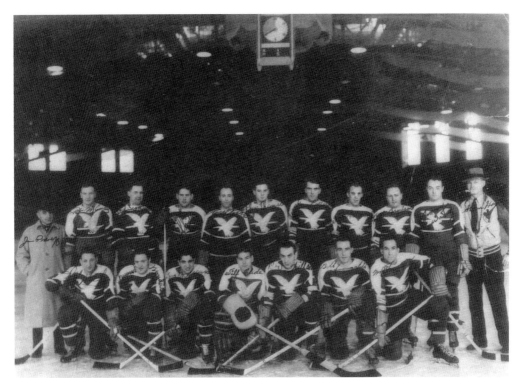

NEW HAVEN EAGLES, 1939–1940. This beautiful team photograph captures the 1939–1940 edition of the New Haven Eagles, seemingly frozen in time. The Eagles were sporting their new uniforms for this campaign, and the boys are proudly representing the New Haven hockey club. If one looks closely at the top of this picture, the old-style time clock can be witnessed hanging from the rafters of the New Haven Arena.

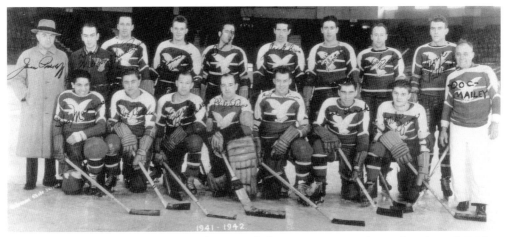

NEW HAVEN EAGLES, 1941–1942. This crystal clear team picture shows the 1941–1942 New Haven Eagles front and center at the New Haven Arena. The team this year featured such star players as Gus Mancuso, Phil Stein, and Joe Shack, who tallied 16 goals and 29 assists for 45 points in 56 games for New Haven that year.

GET THE ARENA HABIT

for wholesome recreation and enjoyment!

☆ ★ ☆

'41 HOCKEY '42

"The World's Fastest Game"

☆ ★ ☆

Follow the Eagles at the New Haven Arena

POCKET SCHEDULE, 1941–1942. There certainly are not too many of these left in existence. Pictured here is a 1941–1942 New Haven Eagles pocket schedule. This was the Eagles' 16th consecutive and last full season of play before the team folded the following season on January 18, 1943. This item was part of the large lot of memorabilia donated to the New Haven Traveling Hockey Museum by the family of Andy and Susan Paris.

EHL PROGRAM, 1943–1944. After folding from the AHL the previous season, the Eagles were back for 1943–1944 in the EHL. The team only lasted about three weeks in New Haven, and this very rare program was from one of the very few home games. The franchise was then shifted to Brooklyn, New York, where it finished the season as the Brooklyn Crescents.

PROGRAM, 1945–1946. For Eddie Shore, who was forced to suspend his Springfield Indians franchise before the 1942–1943 season because of World War II, and operated in New Haven for the 1945–1946 season, this would be his only year in New Haven, and the Eagles posted a dismal 14-38-10 record and finished in last place.

EAGLES PROGRAM, 1950–1951. The Arena Company owned the Elm City's 1950–1951 entry into the AHL, once again called the Eagles. This team was coached by the Eagles' former all-star defenseman Frank Beisler. A miserable 5-23-0 record leading to very poor attendance forced the Eagles to withdraw yet again from the AHL before midseason. This was the final incarnation of the New Haven Eagles.

ALLYN MILLAR

Official Program
NEW HAVEN EAGLES
AMERICAN HOCKEY LEAGUE
LINEUPS SCHEDULES PHOTOS COMMENTS

EAGLES TAKE FLIGHT

RAMBLE ON

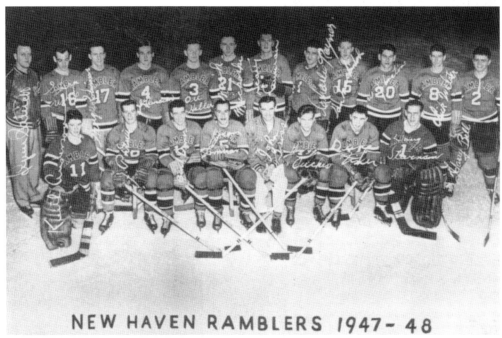

NEW HAVEN RAMBLERS 1947- 48

NEW HAVEN RAMBLERS. The New York Rangers of the NHL owned and operated their top farm club at the arena, the New Haven Ramblers of the AHL (1946–1950). The Ramblers were coached by Hockey Hall of Famer Lynn Patrick (1946–1949) and featured standouts such as Emile Francis, Jack Lancien, Jim Henry, Doug Stevenson, and Jack Gordon. The Ramblers compiled a 98-137-35 regular season record. The Ramblers earned a playoff birth their first two seasons (1946–1948). New Haven went three wins and four losses in three AHL playoff best two out of three series before they rambled out of town.

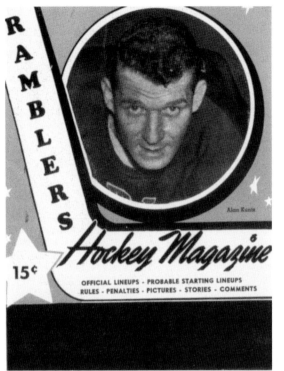

ALAN KUNTZ. The man on the cover of this 1946–1947 New Haven Ramblers program was making his second tour of duty in the Elm City. Alan Kuntz played for the 1941–1942 New Haven Eagles when he scored 14 points and 9 assists in 21 games. As a Rambler in 1946–1947, Kuntz played 55 games, scoring 17 goals and 27 assists for 44 points. He appeared in 14 NHL games with the Rangers in 1945–1946.

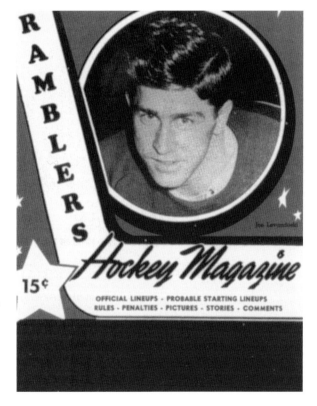

JOE LEVANDOSKI. This former New Haven Eagles (1942–1943) defenseman was assigned to the 1946–1947 New Haven Ramblers by the parent New York Rangers. Joe Levandoski notched 22 points and 10 goals in 47 games for the Ramblers. He also played eight NHL games with New York that same season. Levandoski also played in the AHL with the Buffalo Bisons in 1948–1949 and the Providence Reds in 1953–1954.

SCOTTY CAMERON. After playing 35 NHL games for the New York Rangers in 1942–1943, Scotty Cameron was later assigned to the Rangers' top farm club, the New Haven Ramblers. In two seasons (1946–1948), Cameron played 128 games, netting 24 goals and 41 assists for 65 points for New Haven. He also made other playing stops in St. Paul, Regina, and also with the New York Rovers of the EHL.

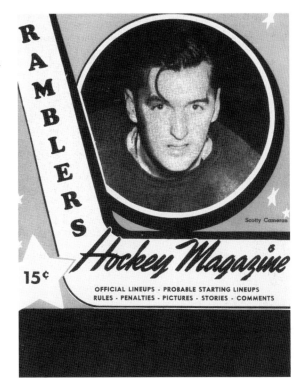

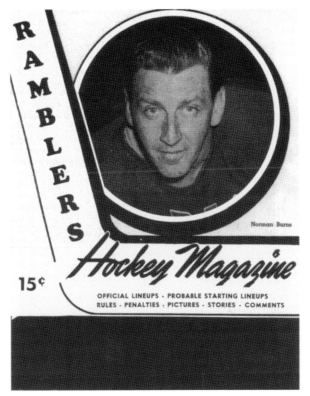

NORMAN BURNS. This speedy center began his career in the EHL in 1939–1940, splitting the season between the Atlantic City Seagulls and the River Vale Skeeters. After a 93-point season with Washington in 1940–1941, Norman Burns split the 1941–1942 campaign between New Haven (AHL) and the New York Rangers (NHL). Burns split 1946–1947 between the Cleveland Barons and the New Haven Ramblers of the AHL.

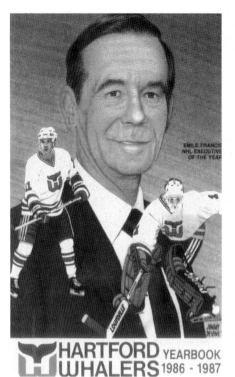

EMILE FRANCIS. One of the most respected men ever in professional hockey, goaltender Emile Francis played 95 NHL games. He tended goal from 1948 to 1950 for the New Haven Ramblers, posting a 37-63-17 record in 117 games. Francis is shown as president and general manager of the Hartford Whalers, where he earned his second NHL Executive of the Year Award in 1985–1986. Francis is in the Hockey Hall of Fame.

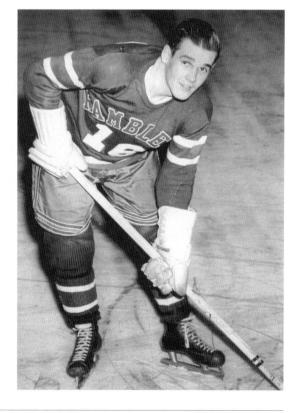

JOE BELL. This former 1945–1946 New Haven Eagles left wing returned to New Haven with the Ramblers in 1946–1947. Joe Bell played 13 games, averaging more than a point per game with 14 points on 10 goals. He was called up to the parent New York Rangers and played 47 games for the blue shirts in 1946–1947. Bell played another nine seasons in professional hockey, finishing up in 1954–1955.

RAMBLE ON

SHELDON BLOOMER. Pictured on the cover of a 1949–1950 New Haven Ramblers program is tenacious defenseman Sheldon Bloomer. During his two seasons (1948–1950) in New Haven, Bloomer was a physical presence on the Ramblers' blue line, racking up 202 PIM, along with 16 points in 136 games. He also made AHL stops in Providence and Syracuse, always exhibiting his physical style of play.

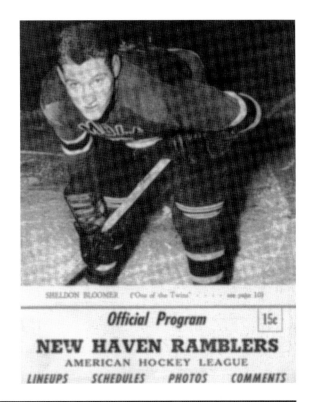

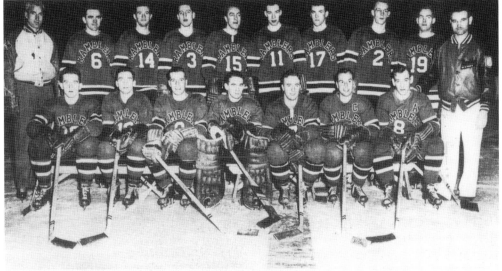

NEW HAVEN RAMBLERS 1949 - 1950

TEAM PHOTOGRAPH, 1949–1950. This was the fourth and final season for the New Haven Ramblers. Although the team improved its record to 24-36-10, compared to 20-40-8 from a year earlier, New Haven still missed the playoffs for the second year in a row. Jack Gordon was the sixth leading scorer in the AHL, with 83 points. The New York Rangers pulled their farm team from the arena after this season.

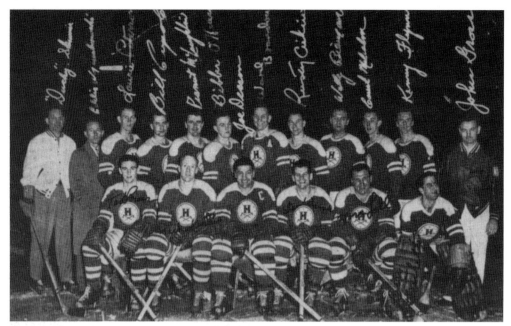

NEW HAVEN TOMAHAWKS TEAM PHOTOGRAPH. After the Arena Company folded the 1950–1951 Eagles of the AHL, it was decided that New Haven would be better off lowering operating costs by placing a team in the EHL. This move brought the Tomahawks for 1951–1952 and the Nutmegs in 1952–1953. These two teams were the lead in acts for the most famous Elm City team of all, the New Haven Blades.

MICKEY KEATING. New Haven fans have always loved the tough guys, and this defenseman always played the game with an edgy fierceness that kept the opposition honest. Mickey Keating began his professional career in 1951–1952 with the New Haven Tomahawks, playing 34 games and adding nine points and 54 PIM. He totaled 734 PIM during his nine-season professional career.

JOE DESSON. Previously, Joe Desson had already built quite a reputation for himself as a tough customer. During the 1951–1952 EHL finals, Desson was called for an infraction. On his way to the penalty box, an incensed Desson lost control. He proceeded to cross-check referee Mickey Slowik in the back of the head, setting off a huge bench-clearing brawl. Desson was subsequently banned for life from the EHL.

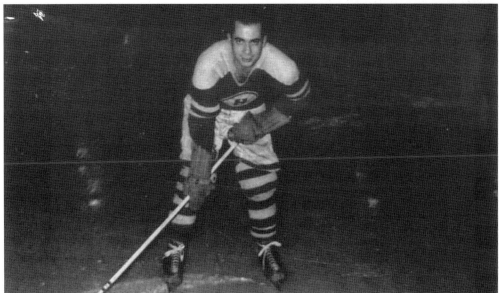

BILL CUPOLO. This former Boston Bruin (1944–1945) and three-year AHL veteran (1945–1948) with Hershey, New Haven, and Springfield was a member of the 1951–1952 New Haven Tomahawks. Bill Cupolo was on the Tomahawks roster for half the season, scoring 29 points in 29 games, on 19 goals and 10 assists. He played the following two seasons in the United States, then finished his career in Italy in 1954–1955.

TOMAHAWKS AT ARENA. Moose Lallo, Bibber O'Hearn, and Ward Brandow line up to see what coach Ducky Skinner has in the briefcase. In the background is one of the Tomahawks' enforcers, Peanuts McLaughlin. The Tomahawks finished in third place, with a 37-27-2 record, and they advanced to the EHL finals, where they were defeated four games to one by the Johnstown Jets.

BIBBER O'HEARN. This high-scoring center began his 10-year professional career in 1951–1952 with the New Haven Tomahawks, helping lead the team to the EHL finals against Johnstown. During the regular season, Bibber O'Hearn tallied 38 goals and 27 assists for 65 points in 64 games. His best season was 1956–1957 for the Charlotte Clippers (EHL), when he scored 117 points on 46 goals and 71 assists in 64 games.

NEW HAVEN NUTMEGS PROGRAM, 1952–1953. New Haven had an entry in the EHL for the second season in a row. This year the team's nickname was the Nutmegs, who finished the year in third place with a 28-31-1 record and lost to Springfield in the first round of the playoffs. The program pictured here is signed by the team, including popular defenseman Ott Heller.

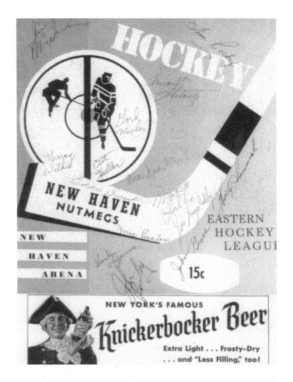

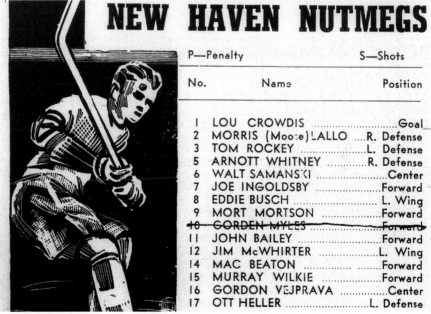

NEW HAVEN NUTMEGS

P—Penalty		S—Shots

No.	Name	Position
1	LOU CROWDIS	Goal
2	MORRIS (Moose) LALLO	R. Defense
3	TOM ROCKEY	L. Defense
5	ARNOTT WHITNEY	R. Defense
6	WALT SAMANSKI	Center
7	JOE INGOLDSBY	Forward
8	EDDIE BUSCH	L. Wing
9	MORT MORTSON	Forward
10	GORDEN MYLES	Forward
11	JOHN BAILEY	Forward
12	JIM McWHIRTER	L. Wing
14	MAC BEATON	Forward
15	MURRAY WILKIE	Forward
16	GORDON VEJPRAVA	Center
17	OTT HELLER	L. Defense

NUTMEGS LINEUP FEATURING OTT HELLER. A two-time Stanley Cup champion with the New York Rangers (1932–1933 and 1939–1940), Heller first played in the Elm City with the New Haven Ramblers (1946–1948). Pictured here is a 1952–1953 New Haven Nutmegs lineup with Heller as player-coach. Previously, as a player-coach, Heller led the Indianapolis Capitals to the AHL's Calder Cup championship in 1949–1950.

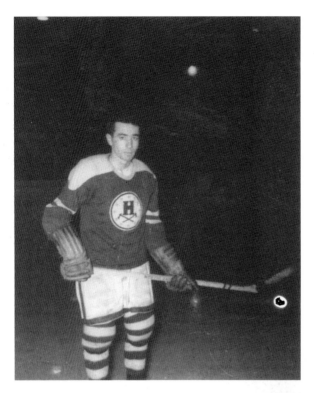

ARTIE CROUSE. Long before his illustrious high school coaching career in West Haven, Artie Crouse played professional hockey at the arena. Crouse played one season each for the New Haven Tomahawks (pictured), New Haven Nutmegs, and New Haven Blades. He played for the New Haven Bears in the Atlantic Hockey League (ATHL) from 1948 to 1951. There is a wonderful display of pictures, trophies, and other items from his high school coaching career at Bennett Rink in West Haven.

MORRIS "MOOSE" LALLO. Moose Lallo played 19 seasons of professional hockey, mainly in the International Hockey League (IHL) and the EHL. Lallo played in 1951–1952 with the New Haven Tomahawks (EHL), as pictured here. He then played the following season with the New Haven Nutmegs (EHL). The rugged defenseman played on four championship teams, Boston (EHL, 1944–1945), San Diego (Pacific Hockey League, 1948–1949), Washington (EHL, 1957–1958), and Jerry DeLisle's Muskegon Zephyrs (IHL, 1961–1962).

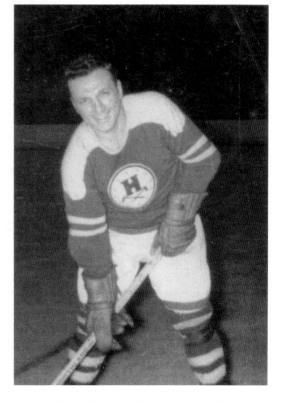

THE GOLDEN AGE OF NEW HAVEN HOCKEY

THE GOLDEN AGE. In 1954, Jerry DeLisle and Harry Glynne III entered the New Haven Blades into the reorganized EHL. In their second season, 1955–1956, the Blades won New Haven's only professional hockey championship, capturing the Boardwalk Trophy over the Johnstown Jets, four games to one. A dispute with arena general manager Nate Podoloff the following year forced Glynne and DeLisle out of the club. Over 18 seasons (1954–1972) the Blades posted a 579-556-86 regular season record, along with a 62-61 postseason mark. The Blades won three division titles (1955–1956, 1960–1961, 1970–1971) and were losing finalists on three occasions (1959–1960, 1960–1961, 1970–1971).

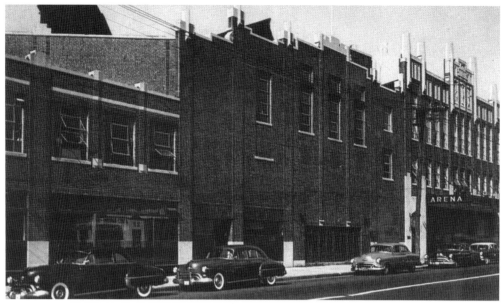

NEW HAVEN ARENA. "The old barn on Grove Street," as it would be known by the latter stages of the New Haven Blades' run in the EHL, is shown in this early-1950s postcard. The New Haven Arena's intimate seating brought the fans right down on top of the action during Blades games, and action there was certainly plentiful.

NEW HAVEN BLADES GAME PROGRAM, 1955–1956. The cost of a program from the Blades championship season was only 15¢. The goalie in the cover illustration is depicted making a save with his eyes closed and a smile on his face. The Blades' real goaltender Murray Dodd's great play all season between the pipes helped New Haven capture the Boardwalk Trophy.

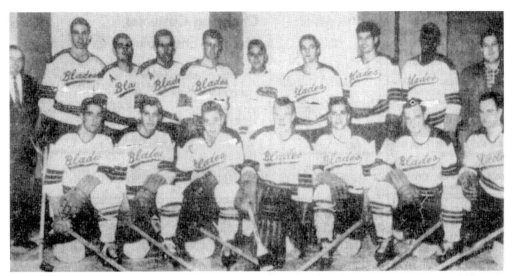

NEW HAVEN BLADES, 1955–1956. The Elm City's only championship team over the course of 76 years of professional hockey was the 1955–1956 team. From left to right are (first row) Ron Kapitan, Claude Boileau, Ron Telford, Murray Dodd, Yvan Chasle, John Sherban, and Joe Buchholz; (second row) co-owner Jerry DeLisle, player-coach Don Perry, Ron Rohmer, Bill MacPherson, Ron Foster, trainer Howie Stringer, Clair Doyon, Rick Albert, Alf Lewsey, and co-owner Harry Glynne.

RON ROHMER. One of the fastest skaters when he turned professional in 1952–1953, Ron Rohmer split the season between the Washington Lions and New Haven Nutmegs. A knee injury slowed him considerably, however, Rohmer played three seasons with the New Haven Blades (1955–1959), scoring 64 points in 56 games for the Blades' 1955–1956 EHL championship team. Rohmer stayed in the New Haven area, becoming a beloved radio personality.

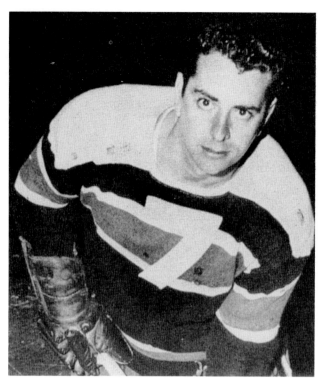

YVAN CHASLE. The C in the Blades' famous "CBS" line that bombarded opposing EHL goalies in the 1950s and a member of the Blades 1955–1956 EHL championship team, left-winger Yvan Chasle played 10 seasons (1954–1964) in New Haven, scoring 334 goals, 312 assists, 646 points, and 131 PIM in 591 games for the Blades. Chasle is the Blades' all-time leading scorer.

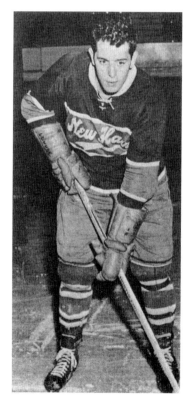

CLAUDE BOILEAU. The B in the famous "CBS" line, Claude Boileau was a talented, hard-nosed center who played 11 seasons (1954–1965) in the EHL. Boileau scored 109 points and 82 assists in 64 games for the Blades 1955–1956 EHL championship team. He scored 158 goals, 369 assists, 527 points, and 448 PIM in 468 games during eight seasons with the Blades (1954–1962). Boileau won another EHL championship with Long Island (1964–1965).

JOHN SHERBAN. The *S* in the New Haven Blades' famous "CBS" line, John Sherban had his best season as a professional during the Blades' 1955–1956 EHL championship year, scoring 49 goals and 60 assists for 109 points and 14 PIM. Sherban began his career with the Johnstown Jets (1952–1953) and then played two seasons (1952–1954) in the IHL. Sherban played 162 games for the Blades from 1954 to 1967, totaling 259 points.

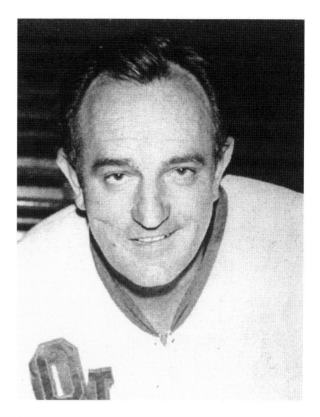

NEW HAVEN GAMES — EASTERN HOCKEY LEAGUE — 1957-1958

HOME GAMES—RED INK AWAY GAMES—BLUE INK

OCTOBER

SUN	MON	TUE	WED	THU	FRI	SAT
		1	2	3	4	5
6	7	8	9	10	11	12
13	14	15	16	17	18	19
20	21	22	23	24	25 (PHIL)	26 (JOHN)
27 (CHAR)	28	29	30 (WASH)	31		

NOVEMBER

SUN	MON	TUE	WED	THU	FRI	SAT
					1 (CHAR)	2 (JOHN)
3	4	5	6 (JOHN)	7	8	9 (CLIN)
10 (CHAR)	11 (PHIL)	12 (PHIL)	13	14	15	16 (WASH)
17 (PHIL)	18	19	20 (CLIN)	21	22	23 (WASH)
24 (CLIN)	25 (PHIL)	26 (JOHN)	27 (WASH)	28	29	30 (WASH)

DECEMBER

SUN	MON	TUE	WED	THU	FRI	SAT
1 (PHIL)	2	3	4	5 (CHAR)	6	7 (CLIN)
8	9	10 (CHAR)	11	12	13	14 (WASH)
15	16	17	18 (JOHN)	19	20	21 (JOHN)
22 (CHAR)	23	24	25 (CLIN)	26 (CLIN)	27	28
29 (JOHN)	30	31				

JANUARY

SUN	MON	TUE	WED	THU	FRI	SAT
			1 (CLIN)	2	3	4 (WASH)
5 (PHIL)	6	7	8 (CLIN)	9	10	11 (CLIN)
12 (JOHN)	13	14 (WASH)	15	16 (WASH)	17	18 (JOHN)
19 (CHAR)	20	21	22 (PHIL)	23	24 (CHAR)	25 (CHAR)
26	27	28 (PHIL)	29	30 (WASH)	31	

FEBRUARY

SUN	MON	TUE	WED	THU	FRI	SAT
						1 (JOHN)
2 (WASH)	3	4	5	6 (CLIN)	7	8 (CLIN)
9 (PHIL)	10	11 (PHIL)	12 (WASH)	13	14	15
16	17	18 (JOHN)	19	20	21	22 (WASH)
23 (CHAR)	24	25 (PHIL)	26	27	28 (CHAR)	

MARCH

SUN	MON	TUE	WED	THU	FRI	SAT
						1 (CHAR)
2 (CLIN)	3	4	5	6 (JOHN)	7 (PHIL)	8 (CLIN)
9 (PHIL)	10	11	12	13	14	15
16	17	18	19	20	21	22
23 / 30	24 / 31	25	26	27	28	29

Week Nite—Time: 8 P.M. Sundays and Holidays—Time: 7:30 P.M.

NEW HAVEN BLADES POCKET SCHEDULE, 1957–1958. Home games were in red ink, away games were in blue ink. Starting times for Blades games this season were 8:00 p.m. on weeknights and 7:30 p.m. on Sundays and holidays. Over the years, during the regular season, Sunday games were played in front of near-capacity crowds (4,000) and weeknights about half capacity (2,000).

GORDIE STRATTON. A veteran of 15 professional seasons (1955–1972), Gordie Stratton played four of them with the New Haven Blades. This high-scoring right wing enjoyed his finest season as a professional with the Blades in 1960–1961, scoring 54 goals and 58 assists for 112 points in 64 games. During four seasons (1957–1961) in New Haven, Stratton scored 297 points on 168 assists in 204 games.

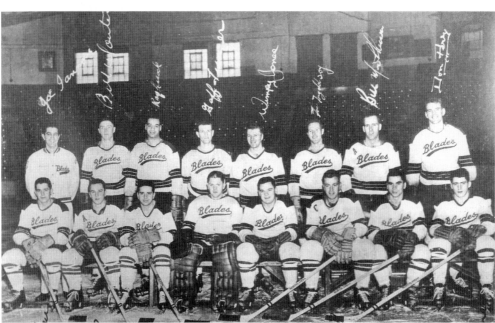

NEW HAVEN BLADES TEAM PHOTOGRAPH, 1957–1958. From left to right are (first row) Claude Boileau, Nick Donaleshen, Yvan Chasle, Gaetan Dessureault, Georges Bougie, Ron Telford, Ken Tressor, and Jacques LaFlamme; (second row) Joe Iannone (trainer), Bill Wouters, Ray Leacock, Gaff Turner, Wimpy Jones, Joe Ingoldsby, Bill MacPherson, and player-coach Don Perry.

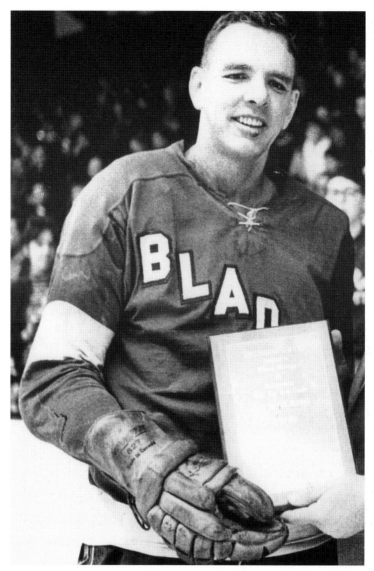

DON PERRY. A New Haven professional hockey treasure, Don Perry is the face of the Elm City's long and glorious love affair with ice hockey. Perry began his career with the Boston Olympics (EHL) in 1950–1951. He then played in Springfield (EHL) and Syracuse (AHL) from 1951 to 1954 for Eddie Shore. At the start of 1954–1955, Perry was out of hockey. A chance meeting with then Blades coach Frank Beisler brought Perry to the Elm City. Over the next eight seasons (1954–1962), Perry was a mainstay on defense for the Blades, as well as serving as a player and coach for several seasons, including the championship 1955–1956 season. Perry left New Haven for the Long Island Ducks (1962–1967) and captured the Walker Cup in 1964–1965. He returned to lead the Blades as player and coach (1967–1969) and coach (1969–1972). Perry won two Turner Cups as head coach of the IHL's Saginaw Gears (1976–1977 and 1980–1981). Perry was head coach of the Los Angeles Kings of the NHL (1981–1984) and also head coach of the New Haven Nighthawks of the AHL (1981–1982 and 1987–1988).

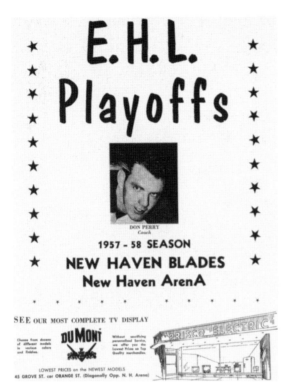

EHL PLAYOFF PROGRAM, 1957–1958. Player and coach Don Perry graces the cover of this New Haven Blades program. Although the Blades had rebounded from the previous year's record with a 33-26-5 mark for the 1957–1958 campaign, and third place again, New Haven still was unable to duplicate the magic of the 1955–1956 championship season.

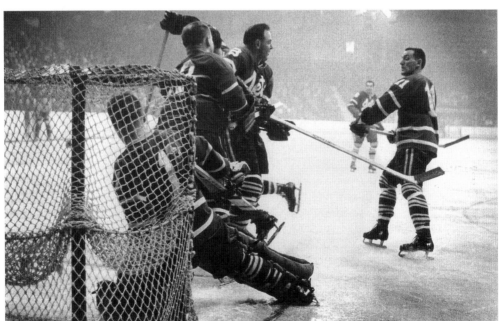

NEW HAVEN BLADES VERSUS JOHNSTOWN JETS. The action is fierce in this early-1960s picture from the New Haven Arena. No helmets and no mask for the goaltender, this is hockey the way it was back in the day. The EHL long had a reputation as a "blood and guts" league. Games between Johnstown and New Haven were no exception to the rule.

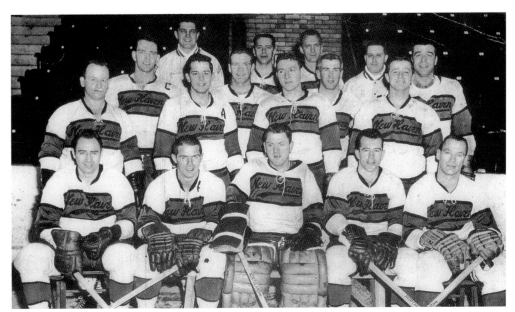

NEW HAVEN BLADES, 1960–1961. Seen here is a souvenir of the New Haven Blades 1960–1961 season. From left to right are (first row) Hugh Riopelle, Don Davidson, Gaetan Dessureault, Jerry Casey, and Gordon Stratton; (second row) Wally Kullman, Claude Boileau, Jack Rogers, and Bob Ertel; (third row) Don Perry, Mike Mahoney, John Brophy, and Ray Crew; (fourth row) trainer Joe Iannone, Yvan Chasle, Fern Bernaquez, and assistant trainer Dick Bonito.

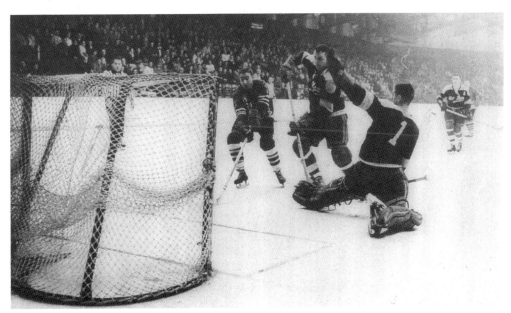

NEW HAVEN BLADES VERSUS LONG ISLAND DUCKS. The puck is on its way into the net, much to the chagrin of the New Haven Blades defense. Fans packed the New Haven Arena to witness the contests between their New Haven Blades and the Long Island Ducks, such as this match from the 1960s at the arena. This is one of many pictures donated to the museum by Phil McDermott.

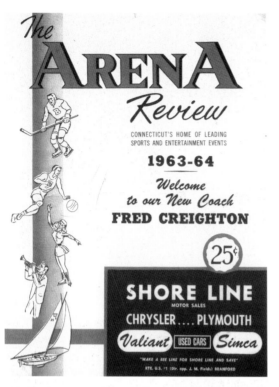

The ARENA
Review

CONNECTICUT'S HOME OF LEADING
SPORTS AND ENTERTAINMENT EVENTS

1963-64

Welcome
to our New Coach
FRED CREIGHTON

25¢

SHORE LINE
MOTOR SALES
CHRYSLER PLYMOUTH
Valiant USED CARS *Simca*
"MAKE A BEE LINE FOR SHORE LINE AND SAVE"
RTE. U.S. #1 (Dir. opp. J. M. Fields) BRANFORD

NEW HAVEN BLADES PROGRAM, 1963–1964. This *Arena Review* welcomes the Blades' new player and coach for 1963–1964, Fred Creighton. New Haven finished the season in fifth place, with a dismal 27-41-3 record. Creighton was not retained after the season. Before coaching Atlanta and Boston of the NHL, Creighton coached the Charlotte Checkers to the 1970–1971 EHL championship, ironically defeating the Blades four games to one.

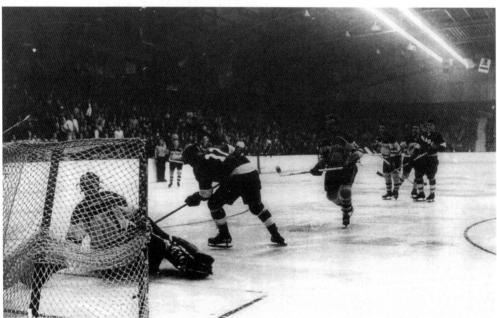

ANOTHER PACKED HOUSE. The New Haven Arena is again packed to its almost-4,000-person capacity for this EHL match between division rivals New Haven and Long Island. Whether the games were played on the Ducks' home ice at Commack Arena or at the New Haven Arena, the action was always lively and true.

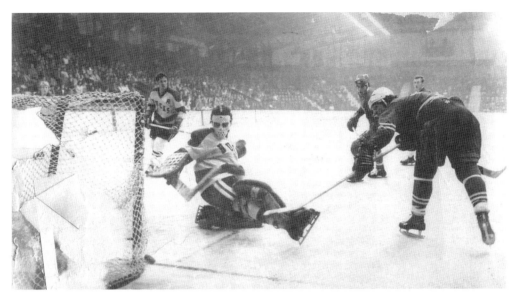

EMPTY SEATS, HELMETS, AND A MASK. Contrary to the wistful recollections of some, all Blades games were not sold out. There are five empty sections in the background, from this 1969 contest between the Blades and the Ducks. The Ducks goalie is sporting a mask, while the two attacking Blades players are each wearing helmets. The EHL shield logo puck is on its way into the net.

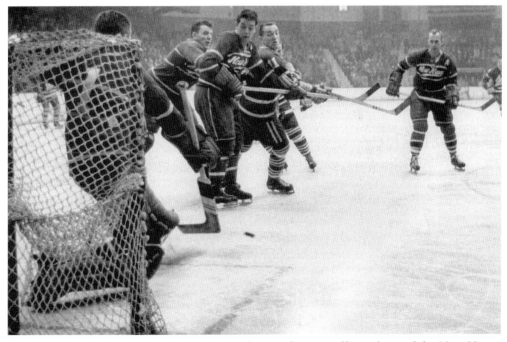

GAETAN DESSUREAULT MAKES A SAVE. With more heavy traffic in front of the New Haven Blades goal, Don Perry clears the front of his zone out, along with a back-checking Claude Boileau in this early-1960s EHL game at a packed New Haven Arena. Gaetan Dessureault was among the EHL's goaltending leaders while with New Haven from 1957 to 1963.

NEW HAVEN
ARENA
Tel. 562-3123

PLEASE EXAMINE TICKETS BEFORE LEAVING WINDOW
TICKETS NOT RETURNABLE FOR REFUND

World Famous JIMMIES
at
Savin Rock

ARENA TICKET ENVELOPE. The Blades at the New Haven Arena and Jimmies restaurant at legendary Savin Rock is a winning combination. This rare piece is highly collectible to New Haven Blades fans and fans of another memory of yesteryear, West Haven's beloved Savin Rock. Jimmies was one of the sponsors of the arena and the Blades. Fans could regularly spot their favorite Blades player enjoying a delicious meal at Jimmies at Savin Rock.

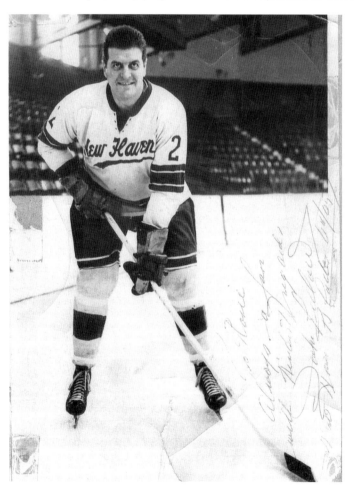

JACKIE LeCLAIR. A member of the 1955–1956 Stanley Cup champion Montreal Canadiens, Jackie LeClair played 138 games for Montreal (1954–1957) and 246 games in the AHL before being named player and coach of the New Haven Blades in 1964. During his three seasons in New Haven, the Blades posted a record of 73-139-4. LeClair played 175 games for the Blades, tallying 229 points, 154 assists, and 214 PIM.

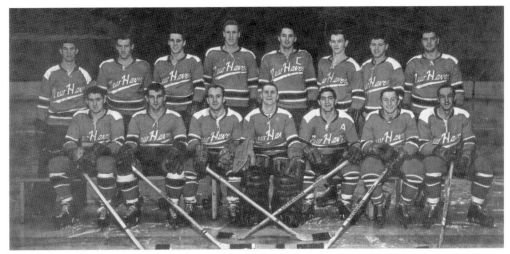

NEW HAVEN BLADES TEAM PHOTOGRAPH, 1965–1966. This picture shows trainer Gunner Garrett in uniform, standing first on the left of the second row. Fourth in from the left of the second row is Blake Ball, with player-coach Jackie LeClair on the end of the second row. The Blades finished in fourth place with a 27-43-2 record and were swept in the first round of the playoffs by Long Island, three games to none.

BLADES BENCH, 1966. This picture shows the Blades player bench at the New Haven Arena, and just how close the fans really were to the action. Not only was there no Plexiglas around the rink (there was chicken wire behind both goals), there also was no barrier between the fans and the player benches, making things quite interesting for visiting teams.

RAY CREW. Pictured here in 1968–1969 as a member of the Syracuse Blazers, at the New Haven Arena, Ray Crew played 15 seasons in the EHL between 1955 and 1970. Crew brought his rugged style of defense to the Blades for three seasons (1959–1962), playing 148 games and earning 58 points on 41 assists while accumulating 318 PIM. He also played for Philadelphia, Knoxville, and New Jersey.

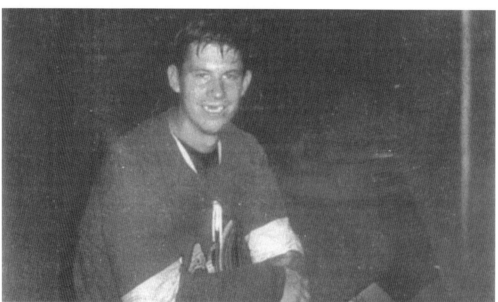

GUNNER GARRETT. Gunner Garrett was the Blades' trainer from the mid-1960s through their final season in 1971–1972. Many teams in the EHL carried only one goalie in those days. Garrett is shown here donning a set of goalie pads, as many EHL trainers also served as backup goalies. He appeared in 22 EHL games as a goaltender, and even once recorded back-to-back shutouts for the Blades.

NEW HAVEN BLADES GAME PROGRAM, 1966–1967. This issue of the *Arena Review* includes an attached sticker on its cover. A reward of $100 was offered for the identification of any persons throwing fireworks of any kind during the game. "Notify The Nearest Policeman Or Usher! The Arena Company." This illustrates the ambitiousness of some arena fans during the Blades era.

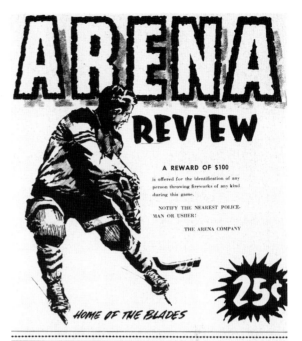

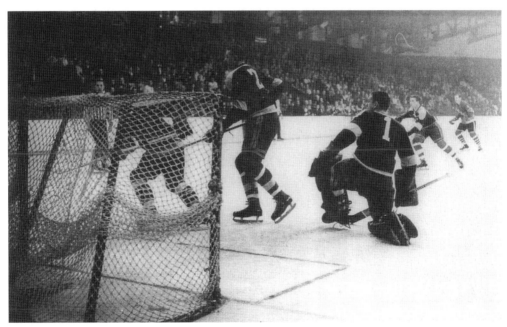

DON PERRY ON DEFENSE. Big Don Perry towers over the opposition in this late-1960s picture. The New Haven Arena is once again filled to its near-4,000-person capacity as the Ducks are visiting again from Long Island. Earlier in his playing career, Perry was the most penalized player in the EHL from 1954 to 1960. Perry ranks third all time in the EHL with 1,935 PIM.

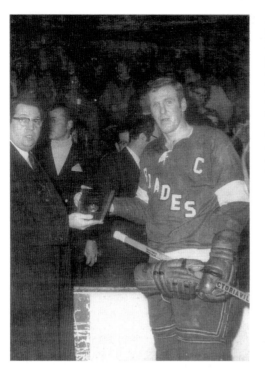

BLAKE BALL. At six feet, four inches, and 225 pounds of brains and brawn from St. Thomas, Ontario, Blake Ball played 4 of his 14 hockey seasons with the New Haven Blades. Ball averaged over 300 PIM a season while playing for the Blades. He was most definitely one of the most feared bad men in the EHL. He accumulated 2,929 PIM during his long playing career.

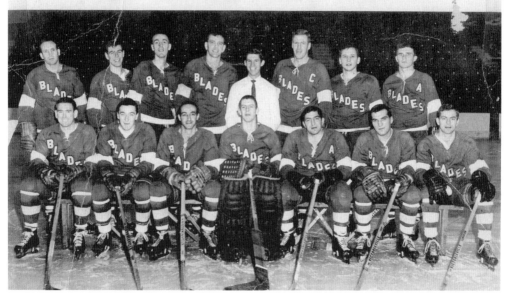

NEW HAVEN BLADES, 1967–1968. Don Perry has returned to New Haven after five seasons (1962–1967) with the Long Island Ducks. From left to right are (first row) Sandy McAndrew, Jean Marie Nicol, Ray Carpentier, Al Johnstone, Ron Hergott, Terry Jones, and Mike Rouleau; (second row) Russ McClenaghan, Don Walker, Larry Brown, coach Don Perry, trainer Gunner Garrett, captain Blake Ball, Bruce Reier, and Murray Kuntz.

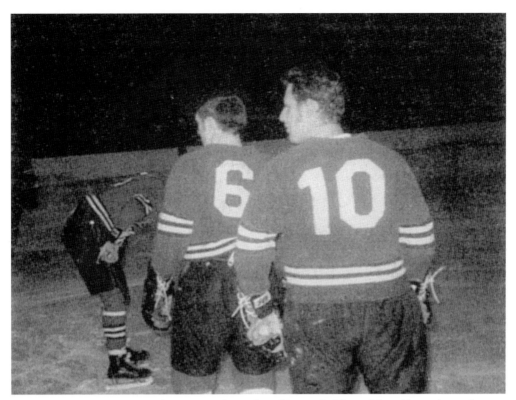

PREGAME WARM-UPS. Dwight Winters (No. 6) and Pierre LeBlanc (No. 10) are shown here at the New Haven Arena during the pregame skate. Winters appeared in 138 games for the Blades (1970–1972), scoring 164 points, including 98 assists. LeBlanc would score 235 points for the Blades, on 117 goals and 118 assists in 208 games from 1969 to 1972.

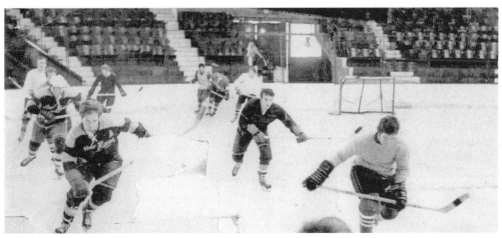

BLADES PRACTICE AT ARENA. An obscure picture shows the New Haven Blades as they hit the ice for practice in the late 1960s. Interestingly, there are two different Blades jerseys being worn by the players, 1967–1968 and 1968–1969. This is one of several pictures that were rescued from the walls of the Arena Grill before demolition of the fabled hockey palace on Grove Street.

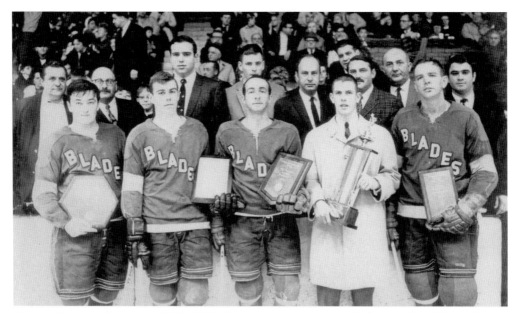

BLADES PLAYER AWARDS, 1967–1968. Receiving various awards for the New Haven Blades 1967–1968 season are, from left to right, Jean–Marie Nicol, Don Walker, Ray Carpenter, Al Johnstone, and Don Perry. This was the final full season for Perry as a player. He injured his knee early the following season (1968–1969) and remained as the Blades' head coach through their final game in New Haven in March 1972.

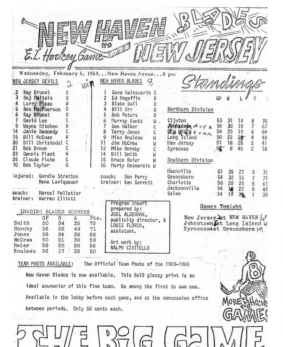

NEW HAVEN BLADES LINEUP SHEET. "February 5, 1969 . . . New Haven Arena . . .8PM . . . New Haven Blades versus New Jersey." This program insert shows the way it was done in the age before computers—typewritten, handwritten, and drawn freehand. This game lineup sheet also promotes the official 1968–1969 New Haven Blades team photograph, available in the New Haven Arena lobby at the price of 50¢ per copy.

THE GOLDEN AGE OF NEW HAVEN HOCKEY

SEASON RESERVATION LETTER. "To the loyal followers of the New Haven Blades; due to the overwhelming number of requests for season reservations for 1969–1970, it is imperative that we have your application with deposit no later than June 30, 1969 to be assured of the same location on record. We look forward to having you with us."

ELM CITY HOCKEY CLUB, INC.
NEW HAVEN
Blades

PRESIDENT
ALBERT DeANGELIS
SECRETARY
MICHAEL CARLONE
TREASURER
NATHAN PODOLOFF

MANAGER-CO
DONALD P
(AREA CODE
466-491
624-947

EASTERN HOCKEY LEAGUE
26 GROVE STREET, NEW HAVEN, CONNECTICUT 06511
TELEPHONE 562-8333
(AREA CODE 203)

June 13,196?

TO THE LOYAL FOLLOWERS OF THE NEW HAVEN BLADES.

Due to the overwhelming number of requests for SEASON RESERVATIONS for 1969–1970, it is imperative that we have your application with DEPOSIT no later than June 30,1969 to be assured of the same location on record.

We look forward to having you with us.

NEW HAVEN BLADES
Albert DeAngelis, President
ELM CITY HOCKEY CLUB, INC

*hu

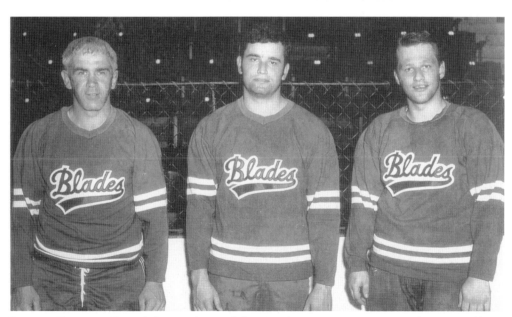

BLADES BADMEN. From left to right are John Brophy, Kevin Morrison, and Pierre Leblanc. While Leblanc was a scrappy and crafty wing for the Blades, Brophy was the all-time penalty minute leader in EHL history and led the circuit in penalty minutes four times from 1960 to 1965—each time with a different team. Morrison, one of the absolute toughest Blades ever, led the EHL with 348 PIM in 1970–1971.

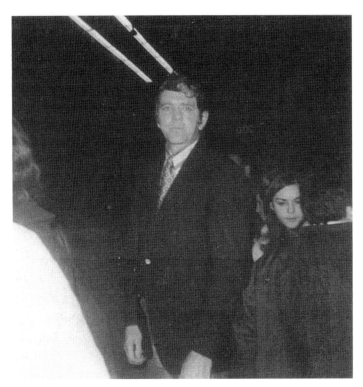

DON PERRY WALKS TO BENCH. Don Perry is pictured here on his way to the Blades bench during the 1970–1971 season. Perry led the Blades to the Northern Division title, with a 38-21-15 record. New Haven dispatched Clinton in five games and swept Johnstown in four games to meet the 55-12-7 Southern Division champion Charlotte Checkers in the EHL finals. Charlotte won the Walker Cup four games to one.

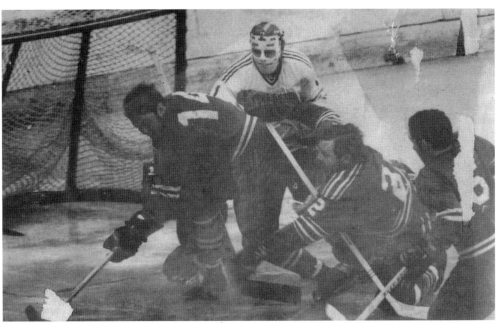

NEW HAVEN BLADES VERSUS CLINTON COMETS. This action from 1970–1971 shows Blades captain Bill Smith (No. 14) cutting toward the Comets goal. Len Speck (No. 2) of Clinton defends while the Blades' Dwight Winters (No. 6) trails the play. The Blades played their chief rivals, the Clinton Comets, more than any other EHL opponent.

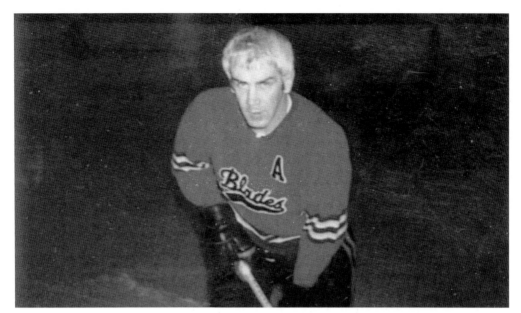

JOHN BROPHY. The EHL's all-time penalty minute leader with 3,825 was John Brophy. Brophy is pictured here in 1969–1970, during his third and final tenure with New Haven. He previously was a Blade in 1958–1959, and again in 1960–1961. Brophy was also a teammate of Don Perry's with the Long Island Ducks from 1964 to 1966, including the Ducks' 1964–1965 EHL championship team.

MIKE HORNBY. This high-scoring Blades center is ready as he makes his way to the arena ice. Mike Hornby rang up 78 goals, 151 assists, 229 points, and 46 PIM in 146 games during his first two seasons with the New Haven Blades from 1968 to 1970. Hornby only played 11 regular season games in 1970–1971 but added 19 points during the Blades' 16-game playoff run.

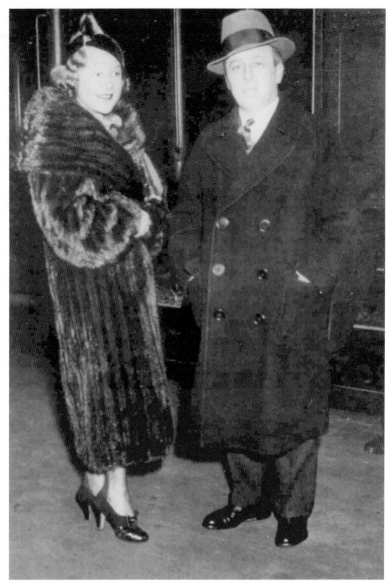

NATE PODOLOFF. In 1926, the New Haven Arena was a partially built venue that was in jeopardy of not being finished. Enter this man, Nate Podoloff, with a degree in civil engineering from Yale's Sheffield Scientific School, class of 1916, who took over the project. Podoloff would finish the construction of the arena with his brothers and have it open for January 1927. Podoloff would be owner and operator of the arena from its opening through its closing in September 1972. He would also own and operate some of the hockey teams that skated at the arena. In 1936, Nate and his brother Maurice were instrumental in the forming of the AHL, along with seven other rink owners who wanted to assure multinight events at their venues. Nate and his wife, Hilda, had a saying, "never a dark night at the Arena." There were so many great nights in that building. Nate is pictured here with three-time Olympic gold-medal figure skating champion Sonia Henie around 1940.

KEVIN MORRISON. Kevin "the Squid" Morrison was one of the most feared of all enforcers to play in New Haven. Morrison led the EHL with 348 PIM in 1970–1971. He played two seasons (1969–1971) with the Blades, totaling 97 points on 62 assists, along with 484 PIM in 112 games. A good hockey player, he played 418 World Hockey Association (WHA) games and also skated in 41 NHL contests with Colorado in 1979–1980.

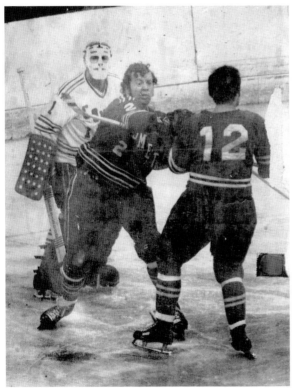

CLINTON COMETS WEARING TWO DIFFERENT JERSEYS. In the EHL, one never knew what could happen. This picture from 1969 shows the Blades' Pierre Brind'Amour (No. 12) in a dark jersey. Notice the Clinton Comets defenseman (No. 2) is also wearing a dark jersey, while the Comets goaltender (No. 1) is wearing a white jersey. Incidents such as this including teams wearing jerseys from multiple seasons during games were not uncommon in the EHL.

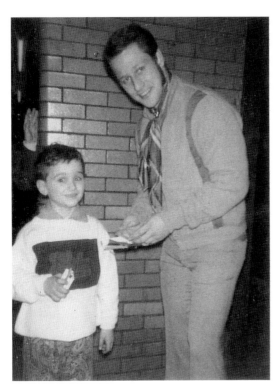

YOUNGSTER RECEIVES AUTOGRAPH.
Here is a happy child, decked out in a
Blades T-shirt, receiving an autograph in
an arena portal from high-scoring Blades
forward Pierre LeBlanc. This photograph
represents much of what New Haven
hockey was, something special passed
down from generation to generation.
Cultivating a young fan base is all part
of the hockey tradition of securing
lifelong fans.

ANDY PARIS. Shown here at the coliseum,
Andy Paris first started as an usher and
attendant at the New Haven Arena in 1940
and worked there until its closing in 1972.
Paris served in the same capacity at the
coliseum, until his retirement in 1990. His
beloved wife, Susan, donated much arena
hockey memorabilia to Kevin Tennyson,
hoping that he would someday present a
book on New Haven hockey.

SEASON TICKET BROCHURE, 1969–1970. Another obscure but historical piece of New Haven Blades paper shows that it was $3 per game for center ice, $2.50 per game from the blue lines to the corners, and $2 per game to sit behind the goal at the New Haven Arena. A season seat at center ice cost $111 for the 1969–1970 season.

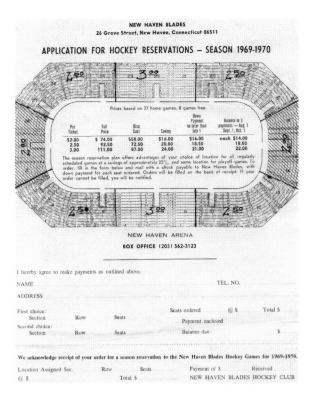

NEW HAVEN BLADES
26 Grove Street, New Haven, Connecticut 06511

APPLICATION FOR HOCKEY RESERVATIONS — SEASON 1969-1970

Prices based on 37 home games, 8 games free

Per Ticket	Full Price	Disc. Cost	Saving	Down Payment no later than July 1	Balance in 3 payments — Aug. 1 Sept. 1, Oct. 1
$2.00	$ 74.00	$58.00	$16.00	$16.00	each $14.00
2.50	92.50	72.50	20.00	18.50	18.00
3.00	111.00	87.00	24.00	21.00	22.00

The season reservation plan offers advantages of your choice of location for all regularly scheduled games at a savings of approximately 22%, and same location for playoff games. To order, fill in the form below and mail with a check payable to New Haven Blades, with down payment for each seat ordered. Orders will be filled on the basis of receipt. If your order cannot be filled, you will be notified.

NEW HAVEN ARENA
BOX OFFICE (203) 562-3123

I hereby agree to make payments as outlined above.

NAME _____ TEL. NO. _____

ADDRESS _____

First choice:
Section _____ Row _____ Seats _____ Seats ordered _____ @ $ _____ Total $ _____
Payment enclosed _____
Second choice:
Section _____ Row _____ Seats _____ Balance due _____ $ _____

We acknowledge receipt of your order for a season reservation to the New Haven Blades Hockey Games for 1969-1970.

Location Assigned Sec. _____ Row _____ Seats _____ Payment of $ _____ Received _____
@ $ _____ Total $ _____ NEW HAVEN BLADES HOCKEY CLUB

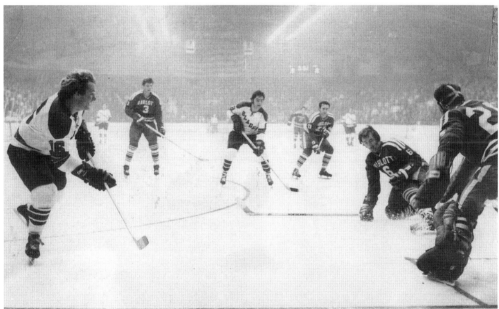

ELGIN McCANN. This rare photograph captures EHL game action between the New Haven Blades and the Charlotte Checkers during the Blades' final season (1971–1972) at the New Haven Arena. Cigar and cigarette smoke lingers over the rink while No. 16 of the Blades, Elgin McCann, anticipates a potential rebound he hopes to sneak past the Checkers' goaltender.

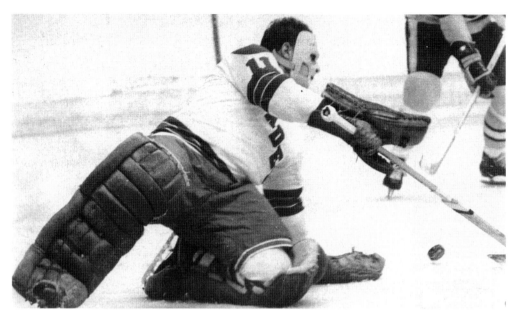

JIM ARMSTRONG. Best remembered for tackling linesman Gordie Heagle in the early stages of Game 7 of the Blades' 1971–1972 first-round playoff series versus Syracuse, while coming to the aid of teammate Blaine Rydman, is Jim Armstrong. This turned out to be the final New Haven Blades game ever. Armstrong was a fine goaltender who also played for Long Island, Rhode Island (EHL), Seattle, Salt Lake City (WHL), Toledo, and Saginaw (IHL).

DAVE HAINSWORTH. One of the most popular players in New Haven history, Dave Hainsworth played 186 games for the Blades from 1968 to 1972. He shut out the Clinton Comets three straight games in the 1969–1970 playoffs to force a decisive Game 7. The Blades lost Game 7 when Clinton scored a goal allegedly through a hole in the side of the net. Hainsworth later played for the Nighthawks and Senators.

THE GOLDEN AGE OF NEW HAVEN HOCKEY

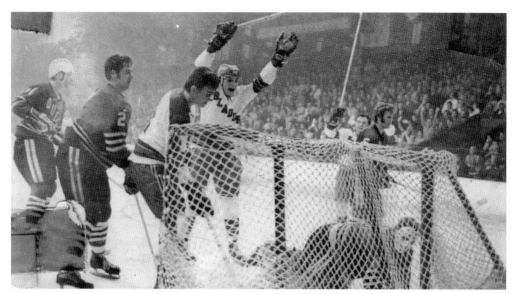

DAVE HRECKOSY. The "wrecker" Dave Hreckosy celebrates a goal against the Long Island Ducks during the 1971–1972 season. The packed New Haven Arena joins in unison. Hreckosy scored 66 points, including 34 assists in 75 games for the Blades. He also played 141 NHL games for California and St. Louis, tallying 66 points on 42 goals and 24 assists. He also played 62 games for the New Haven Nighthawks (AHL, 1978–1980).

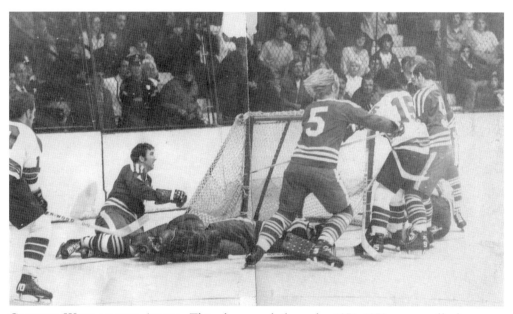

CHICKEN WIRE AT THE ARENA. This photograph from the 1971–1972 season affords a great look at the chicken wire fencing that was behind both goals at the New Haven Arena. This rink did not have any protective barrier above the boards anywhere else except behind the goals. No. 15 is the Blades' Andre Peloffy, who scored 76 points on 44 assists in 42 games that year in New Haven.

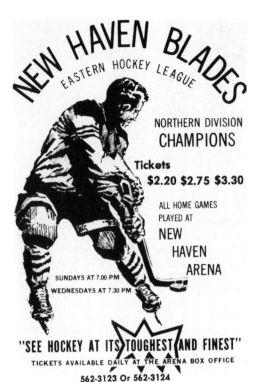

HOCKEY AT ITS TOUGHEST AND FINEST.
With only five regular season games remaining in their final season (1971–1972) in New Haven, this Blades advertisement, on the back cover of the February 27, 1972, *New Haven Register* "TV Facts," shows the classic marketing of the team. The slogan is "See Hockey at its Toughest and Finest." Ticket prices to see the defending Northern Division champions were $2.20, $2.75, and $3.30 per game.

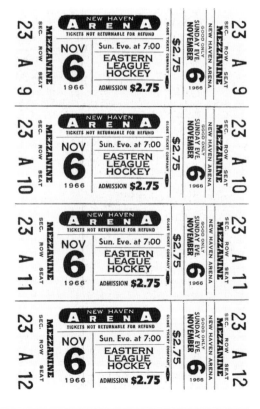

NEW HAVEN ARENA EHL TICKETS. These unused tickets to a 1966 New Haven Blades game, on Globe Ticket Company stock, although rare, are more common than their 1970s counterparts from the New Haven Veterans Memorial Coliseum. While the coliseum would return its unused tickets to the manufacturer, the New Haven Arena kept its unused tickets for other usage. After the arena closed, thousands of these tickets littered the box office floor, and many were rescued.

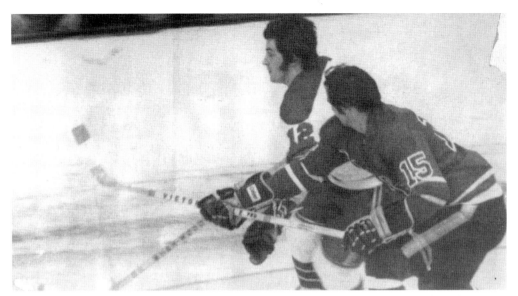

PIERRE BRIND'AMOUR. Shown here stickhandling past a Long Island Ducks defender, Pierre Brind'Amour was drafted by the New York Rangers, 106th overall in the 1970 NHL amateur draft. He played two seasons (1970–1972) in New Haven and was instrumental in helping the Blades advance to the 1970–1971 EHL finals. Brind'Amour scored 160 points and 99 assists in 140 games during his two seasons in New Haven.

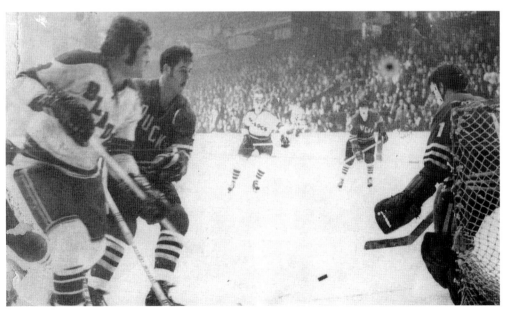

NEIL CLARK. The New Haven Arena is full to its capacity in this picture from the 1971–1972 season. Blades center Neil Clark is moving toward the Long Island goal, trying to beat the Ducks defense to the rebound. Clark played two seasons (1970–1972) for the Blades, scoring 168 points and 96 assists in 140 games. Clark also played one game for the New England Blades the following season (1972–1973).

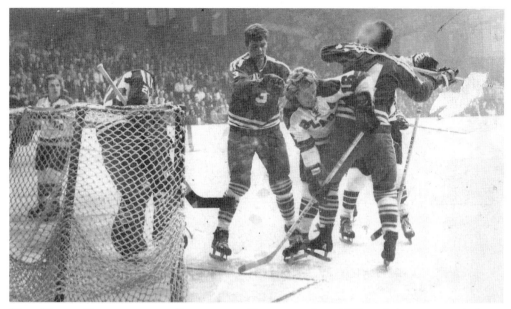

New Haven Blades versus Charlotte Checkers. It is 1972 and there are no helmets in this picture from the New Haven Arena. Elgin McCann (No. 16) of the Blades is hit from behind, while No. 4 of the Checkers cross-checks an unidentified New Haven player in the head. This is typical of the physical nature of the EHL, and the fans loved their New Haven Blades.

Final Season Blades Program, 1971–1972. The *Arena Review* for the final New Haven Blades season is a stand-alone design. The cover is different than its predecessors of 1966 through 1971, which were basically the same during those years. The 1971–1972 *Arena Review*, with its brown background and bright orange letters, stands out among its peers. This is the rarest of the late-model Blades programs.

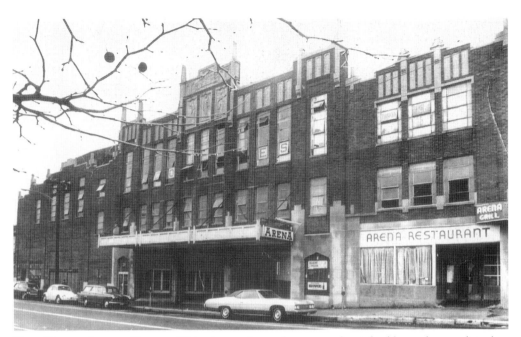

NEW HAVEN ARENA CLOSED. This picture shows the arena after it had been shuttered, its last event being an Elton John concert in September 1972. The building would become a home for vagrants and such, until it was demolished in the spring of 1975. The building was stripped of its copper pipes, radiators, and other scrap metals by industrious individuals. The New Haven Arena will never be forgotten by all those who loved it.

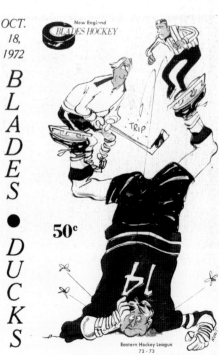

NEW ENGLAND BLADES GAME PROGRAM, 1972–1973. Nate Podoloff, after being refused ice time at the coliseum, moved the Blades temporarily to the Eastern States Coliseum in West Springfield, Massachusetts, for the 1972–1973 EHL season. Podoloff intended to play there for two seasons and then move the Blades to the brand-new Hartford Civic Center for 1974–1975. Unfortunately, New England folded 24 games into the 1972–1973 season.

THE NEW HAVEN ARENA

By Maria A. Smith

An old arena worn with age,
yet a castle in my mind.
for within its craggy walls,
I spent the happiest of times.

Though it was aged and shabby,
it held a warmth all its own.
With friendly faces all about,
To so many it was home.

Memories it held within,
time can't possibly erase.
Nor can any other building,
ever take its place.

Much of my life was spent,
within the old brick walls.
Never dreaming that someday,
the big old place would fall.

I felt a silent sadness,
as I stood by to see,
the Arena crumble to the ground,
burying with it part of me.

ARENA POEM BY MARIA A. SMITH. This poem by Maria A. Smith that was discovered in a lot of memorabilia donated to the New Haven Traveling Hockey Museum by the Paris family sums up the feelings of so many people who attended hockey games (and other events) at the New Haven Arena: "I felt a silent sadness, as I stood by to see, the Arena crumble to the ground, burying with it a part of me."

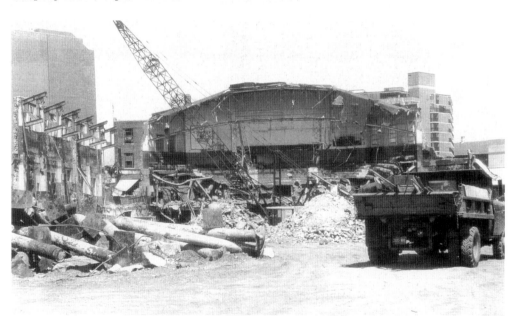

NEW HAVEN ARENA DEMOLITION. If one looks closely, the scoreboard can still be seen hanging on the rear wall of the New Haven Arena, never to read 19:59 again. Although the city of New Haven had opened its state-of-the-art New Haven Veterans Memorial Coliseum in September 1972, many Blades fans from the arena never set foot in the new building, preferring to let their hockey memories remain buried forever on Grove Street.

THE GOLDEN AGE OF NEW HAVEN HOCKEY

4

LET'S GO 'HAWKS

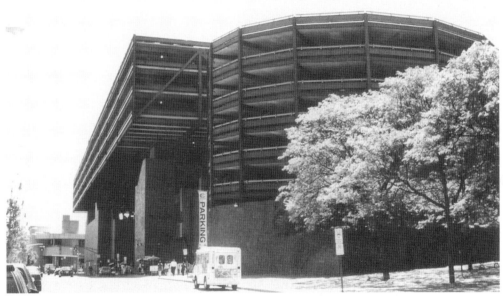

NEW HAVEN VETERANS MEMORIAL COLISEUM. The brand-new home of the Elm City's new AHL team, the New Haven Nighthawks, is seen here. The perseverance of Greg McCoy, Jack McColl, Karl Marsh, Peter Ciardello, and MacGregor Kilpatrick (sports associates) finally came to fruition with the inaugural season of the New Haven Nighthawks (1972–1973). Originally affiliated with the New York Islanders and Minnesota North Stars, the 'Hawks would have working agreements over the years with Detroit, Los Angeles, and the New York Rangers. Joel Schiavone bought the Nighthawks on March 3, 1979, and owned the team for four years. He stayed on the board of directors after he sold the team to the Los Angeles Kings in 1983. The Kings owned the franchise until they sold it to Peter Shipman, who operated the team as an independent in 1991–1992. The 'Hawks' 20-year AHL record was 699-705-180, as well as a playoff record of 53-70. The Nighthawks made the AHL playoffs 14 out of 20 seasons, including four appearances in the Calder Cup Finals (1974–1975, 1977–1978, 1978–1979, and 1988–1989), but were never able to capture the championship.

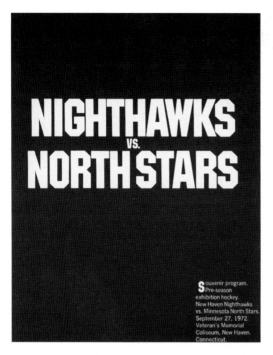

NIGHTHAWKS
vs.
NORTH STARS

Souvenir program.
Pre-season
exhibition hockey.
New Haven Nighthawks
vs. Minnesota North Stars.
September 27, 1972.
Veteran's Memorial
Coliseum, New Haven,
Connecticut.

FIRST EVENT EVER IN COLISEUM. The New York Islanders and Minnesota North Stars shared the New Haven Nighthawks as their AHL affiliate in 1972–1973. The program pictured here is from the first event ever held in the still not quite completed New Haven Veterans Memorial Coliseum, September 27, 1972. This was the first in a long series of exhibition games between the Nighthawks and NHL teams at the coliseum.

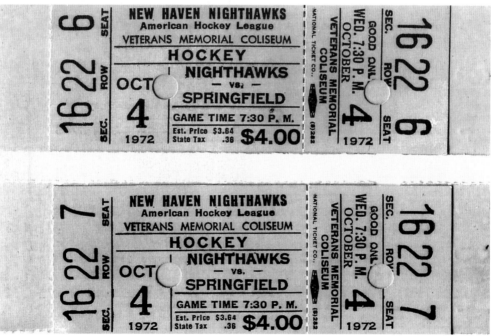

REGULAR-SEASON OPENING-NIGHT TICKETS. Here is a pair of tickets from October 4, 1972, at the New Haven Coliseum. The Springfield Indians stopped in for their first of many visits to the New Haven Veterans Memorial Coliseum. The 1972–1973 Nighthawks featured several future Islander greats, including Bob Nystrom, Chico Resch, and Garry Howatt. Former New Haven Blades Elgin McCann and Kevin Morrison were also on the 'Hawks roster.

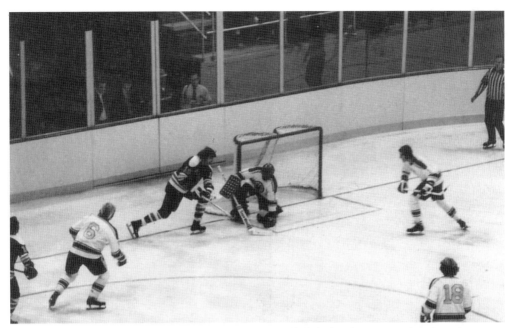

CHICO RESCH. The expansion Nighthawks roster included this future Stanley Cup champion New York Islanders goaltender (1979–1980). Before he would go on to a 14-year (1973–1987) NHL career, in which he compiled a 231-224-82 record in 571 games played, Chico Resch was an original New Haven Nighthawks goaltender. The man behind the red mask appeared in 43 games for the 1972–1973 Nighthawks, going 7-21-14.

SKEETER TEAL. This center was selected by the St. Louis Blues, 42nd overall in the 1969 NHL entry draft. Skeeter Teal was a member of the inaugural season of the New Haven Nighthawks in 1972–1973. He played 69 games for New Haven, scoring 18 goals and 34 assists totaling 52 points and six PIM. Teal played three more seasons of professional hockey (1973–1976).

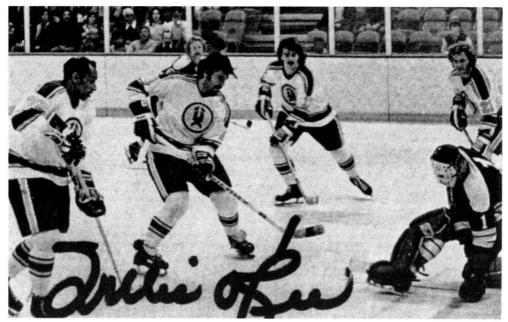

WILLIE O'REE. Willie O'Ree, far left No. 22, was the first African American to play in the NHL when he played for the Boston Bruins on January 18, 1958. Playing 45 games for the Bruins (1957–1958 and 1960–1961), O'Ree scored 4 goals, 10 assists, 14 points, and 26 PIM. After 11 seasons in the WHL (1961–1972), O'Ree played 50 games for New Haven in 1972–1973, scoring 45 points and 21 goals.

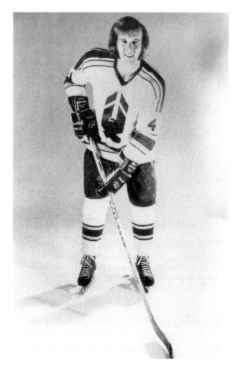

STEVE WEST. Steve West was the AHL's leading scorer in 1973–1974 with 50 goals, 60 assists, 110 points, and 41 PIM in 76 games with the Nighthawks. He was also the first player in 'Hawks franchise history to net 50 goals in a single season. West played 142 WHA games for the Houston Aeros and Winnipeg Jets (1975–1979), collecting 79 points and 50 assists.

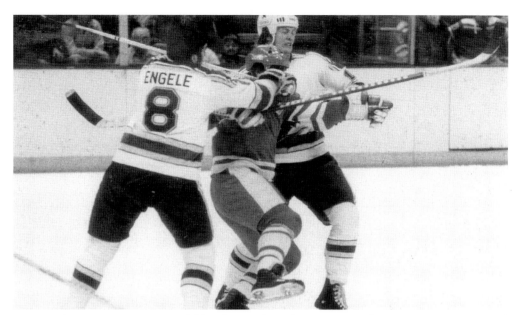

JEROME ENGELE. A very rugged blue liner who split 1974–1977 between New Haven and Minnesota (NHL), Jerome Engele played a solid game and always protected his Nighthawks teammates. Over three seasons, he played 185 games and accumulated 498 PIM to go along with 72 points for the 'Hawks. Engele played 100 NHL games with the North Stars, scoring 15 points while adding 162 PIM.

ALAIN LANGLAIS. Tom Colley's left wing with the 'Hawks from 1973 to 1976 scored 138 points on 76 goals in 148 games for New Haven, along with 220 PIM. Alain Langlais played in the EHL with the Jersey Devils and the Long Island Ducks (1970–1972). Langlais also appeared in 25 NHL contests for Minnesota (1973–1975), scoring four goals and four assists for eight points with 10 PIM.

JERRY BYERS. A favorite of Nighthawks fans, this first-round draft choice of the Minnesota North Stars (1972) was assigned to New Haven in 1973–1974 after starting the season with Minnesota. Jerry Byers played 213 games with New Haven (1973–1974 and 1976–1978), scoring 94 goals, 112 assists, 206 points, and 68 PIM. Byers played 45 NHL games with Minnesota, Atlanta, and the New York Rangers.

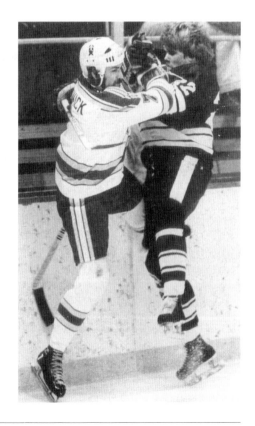

RICK CHINNICK. Rich Chinnick is shown here colliding with an opponent at the New Haven Veterans Memorial Coliseum, also known as the Vet. Chinnick was a Nighthawk for three seasons (1974–1977), scoring 59 goals, 72 assists, for 131 points, and 39 PIM in 209 games played. Chinnick was instrumental in the 'Hawks' advancement to the 1974–1975 Calder Cup Finals as he scored 17 points on 10 goals in 16 playoff games. He also played four NHL games with Minnesota (1973–1975).

LET'S GO 'HAWKS

SCOTT MACPHAIL. The other wing on the Tom Colley line, Scott MacPhail was a tireless worker who opened up the ice for linemates Alain Langlais and Colley. MacPhail played four years in New Haven (1973–1977), scoring 97 points, 45 goals, and 107 PIM in 186 games. MacPhail added 19 points in 27 playoff games, including 12 points in 16 games during the Nighthawks' remarkable run to the 1974–1975 Calder Cup Finals.

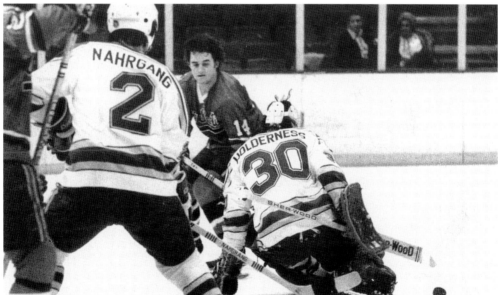

BRIAN HOLDERNESS. Brian Holderness had a record of 17-16-5 and a 4.06 goals against average (GAA) in 39 regular season games for the 'Hawks in 1974–1975. He caught fire and backstopped New Haven all the way to the Calder Cup Finals, as the one and still only fifth-place team to do so. The magic ended, however, as the Springfield Indians won the cup four games to one. Holderness played 1975–1976 in New Haven, going 12-15-2 with a 3.43 GAA.

EDDIE JOHNSTONE. In the 1976–1977 AHL season, Nighthawks right-winger Eddie Johnstone was selected to the all-star team. He scored 40 goals and 58 assists for 98 points. After 17 games in New Haven the following year (1977–1978), Johnstone was called up to the NHL by the parent New York Rangers and stuck in the NHL for the next five years.

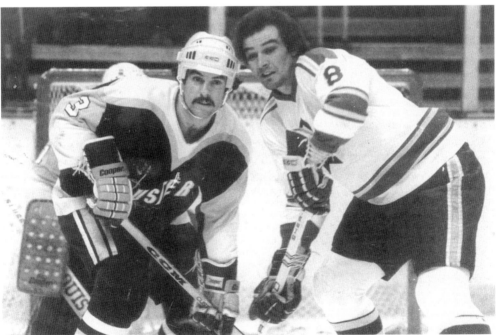

KEN HODGE. A two-time Stanley Cup champion with Boston (1969–1970 and 1971–1972), Ken Hodge scored 800 points with 472 assists and 779 PIM in 881 NHL games with Chicago, Boston, and the Rangers (1964–1978). He is shown here as a New Haven Nighthawk playing against the Binghamton Dusters in 1977–1978. Hodge's 46 points in 52 games helped the 'Hawks advance to the Calder Cup Finals and earned him the team's MVP award.

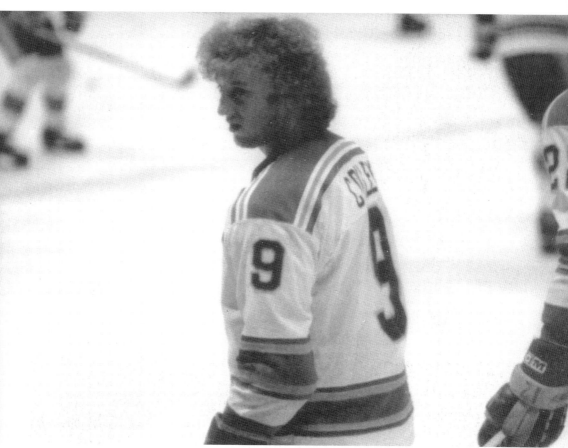

TOM COLLEY. Mr. New Haven Nighthawk, Tom Colley was the only player to have his number retired (No. 9) in New Haven history. Colley's No. 9 was actually retired at the New Haven Veterans Memorial Coliseum twice. The first time was by the Nighthawks during the 1984–1985 season. When the Nighthawks/Senators franchise moved following the 1992–1993 season, leaving the coliseum vacant, team owner Peter Shipman had the No. 9 banner sent to Colley in Collingwood, Ontario, where he still has the banner today. During their inaugural season in 1997–1998, the Beast of New Haven (who did not issue No. 9 to any player) re-retired Colley's No. 9, hanging a new banner from the coliseum rafters. Colley is the Nighthawks' all-time franchise leader in games played (534), goals (204), assists (281), and total points (485), while adding 234 PIM in seven seasons (1973–1980). Colley is the most popular Nighthawk of all time. He was the captain of the Nighthawks.

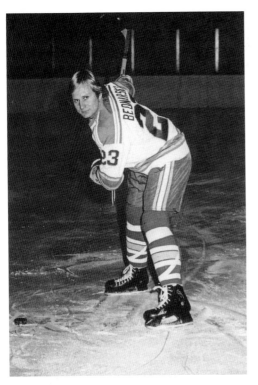

BOB STEFANSKI. Pictured here posing while wearing teammate John Bednarski's No. 23 jersey, Bud Stefanski played 166 games for New Haven, scoring 160 points, 100 assists, and 202 PIM from 1977 to 1982. Stefanski played the 1980–1981 and 1981–1982 seasons in Austria, then joined the 'Hawks for the end of the AHL regular season and playoffs both years. Stefanski won a Calder Cup with the Maine Mariners in 1983–1984.

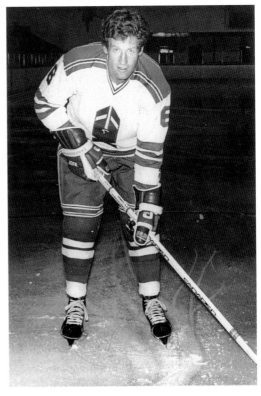

RAY CLEARWATER. Ray Clearwater played earlier in the Elm City with the New Haven Blades from 1963 to 1966, appearing in 201 games, scoring 143 points with 95 assists and 148 PIM. Clearwater came to the Nighthawks after seven years in the AHL (1966–1972 and 1975–1976) and four years in the WHA (1972–1977). Clearwater played three seasons, 162 games, with the Nighthawks, scoring 55 points, 44 assists, and 132 PIM (1977–1980).

LET'S GO 'HAWKS

DALE LEWIS. The deafening chant of "Lou-ie, Lou-ie" filled the New Haven Veterans Memorial Coliseum. The hero was Dale Lewis when he scored in sudden-death overtime to catapult the Nighthawks past the Rochester Americans and into the 1977–1978 Calder Cup Finals against the Maine Mariners. Lewis played four seasons for the Nighthawks during his nine-year professional career, tallying a total of 237 points in 299 games.

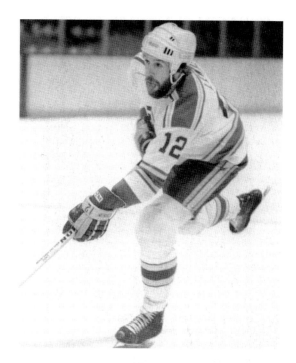

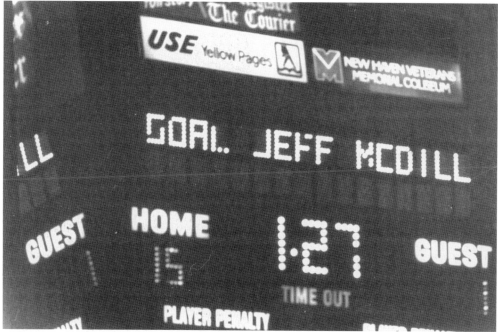

SCORED 15 GOALS. On April 23, 1979, the New Haven Veterans Memorial Coliseum scoreboard tells no lies; home 15, guest 1. Jeff McDill's third-period goal was the Nighthawks' 15th of the evening against the Binghamton Dusters in Game 3 of their second-round 1978–1979 AHL playoff series. The Nighthawks won the series four games to two to advance to the Calder Cup Finals, where the Maine Mariners defeated New Haven for the second year in a row.

DAN CLARK. Another tough, solid Nighthawks defenseman, Dan Clark was feared by the opposition, all the while playing a steady blue line for the 'Hawks. The aggressive Clark played 210 games, scoring 73 points, including 62 assists, and 612 PIM for New Haven from 1978 to 1981 and 1985 to 1986. Clark played four games for the New York Rangers (NHL) in 1978–1979, registering one point.

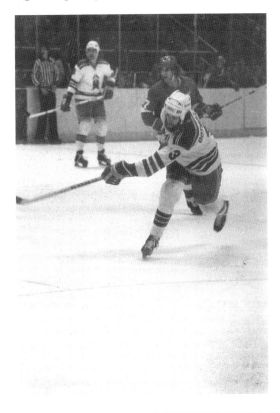

TIM BOTHWELL. This talented defenseman turned professional with the 'Hawks in 1978–1979. Tim Bothwell split time between New Haven and the New York Rangers from 1978 to 1981. Bothwell played 502 NHL games for the Rangers, Blues, and Whalers, scoring 121 points, 93 assists, and 382 PIM. He finished his playing career with the Nighthawks in 1989–1990. In 236 games, he scored 153 points, 119 assists, and 223 PIM for the 'Hawks.

LET'S GO 'HAWKS

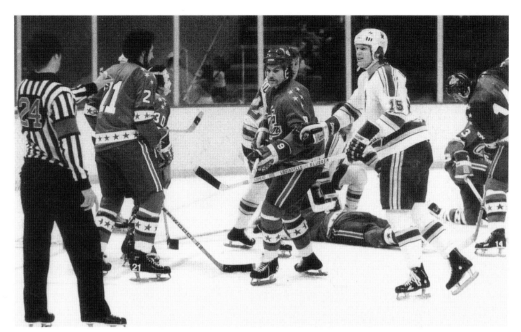

BILL LOCHEAD. Bill Lochead first played for the Nighthawks in 1975–1976, the year Minnesota shared the affiliation in New Haven with the Detroit Red Wings. Lochead returned as a Nighthawk in 1979–1980 as New York Rangers property and scored an AHL-record seven hat tricks, en route to 46 goals in only 68 games. If New York had not recalled him for seven games, Lochead may have scored 50 goals.

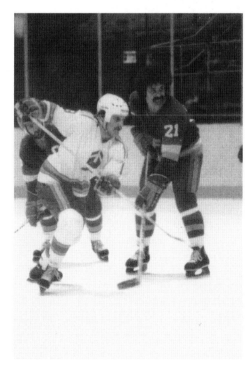

FRANK "NEVER" BEATON. One of the all-time favorites of Nighthawks fans, Frank "Never" Beaton arrived in the Elm City in 1978, with his pugilistic reputation from the WHA preceding him. "Beater" kept the 'Hawks opponents honest from 1978 to 1980, playing 129 games, scoring 55 points on 17 goals and 38 assists, while racking up 445 PIM. Beaton is shown here versus the Philadelphia Firebirds at the coliseum.

Bobby "the Cat" Sheehan. A Stanley Cup champion with the 1970–1971 Montreal Canadiens, Bobby "the Cat" Sheehan was one of the most gifted players of this era. Some argue that if Sheehan had applied himself more, his career would have been even more impressive. He played 200 games for the Nighthawks (1977–1980 and 1981–1982), scoring 75 goals, 98 assists, 173 points, and 74 PIM.

Mike Backman. This scrappy right-winger turned professional with the Toledo Goaldiggers of the IHL in 1978–1979. Mike Backman played 218 games for the Nighthawks, scoring 160 points, 103 assists, and 504 PIM from 1978 to 1981 and 1984 to 1986. Backman played 18 NHL games for the Rangers (1981–1984), with seven points and 18 PIM. His tenacious style of play endeared him to Nighthawks fans.

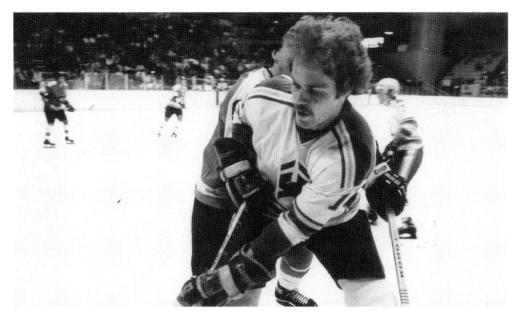

MIKE MCDOUGAL. A big right wing (six feet, two inches, and 200 pounds), Mike McDougal played three seasons (1978–1981) with the Nighthawks and was a big part of their success. McDougal played 212 games for the 'Hawks, scoring 62 goals and 74 assists for 136 points and 123 PIM. He also played 61 NHL games (1978–1983) with the New York Rangers and Hartford Whalers.

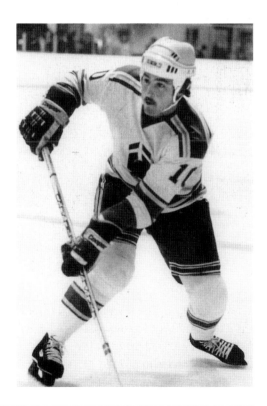

CLAUDE LAROSE. Claude Larose played 252 WHA games with Cincinnati and Indianapolis (1975–1979), scoring 202 points on 88 goals and 114 assists, before joining the Nighthawks midway through the 1978–1979 season. Splitting 1979–1980 between New Haven and the New York Rangers, he played 25 NHL games. Larose scored 150 points in 153 games on 71 goals and 79 assists as a Nighthawk from 1978 to 1981.

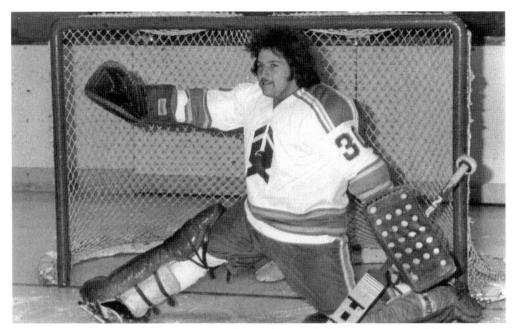

LINDSAY MIDDLEBROOK. The "China Wall" backstopped the 1978–1979 Nighthawks to the Southern Division title and an appearance in the Calder Cup Finals, leading the AHL with 54 games played, 29 wins, and 3,221 minutes played. Lindsay Middlebrook's record with the 'Hawks was 34-28-8 in his two seasons here (1977–1979). Middlebrook played 37 NHL games from 1979 to 1983 with Winnipeg, Minnesota, New Jersey, and Edmonton.

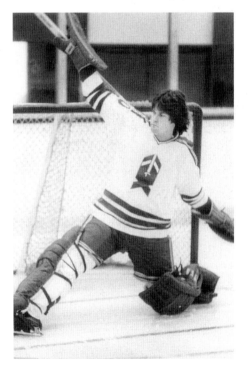

STEVE BAKER. The 44th overall pick in the 1977 entry draft by the New York Rangers, Steve Baker was assigned to Toledo (IHL) for the end of the 1977–1978 season. Baker played parts of three seasons (1978–1981) with the Nighthawks, appearing in 58 games, with a 31-17-9 record. Baker played 57 games with the Rangers (NHL), going 20-20-11. He won a Calder Cup with Maine (AHL) in 1983–1984.

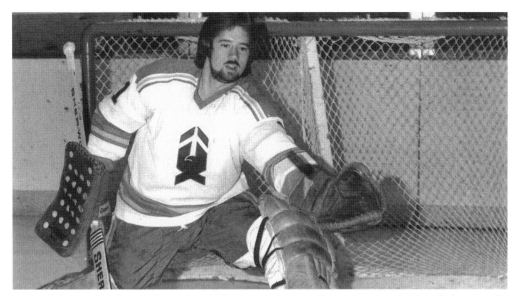

DOUG SOETAERT. "Soapy, Soapy" was the cry every time Doug Soetaert manned the nets for the New Haven Nighthawks. Soetaert split five seasons bouncing back and forth between the Nighthawks and their then parent team the New York Rangers (1976–1981). He spent parts of 12 seasons in the NHL. His name is forever engraved on the Stanley Cup as a member of the 1985–1986 Montreal Canadiens.

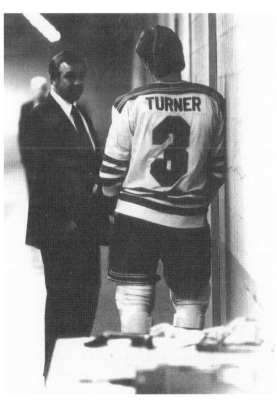

PARKER MACDONALD AND DEAN "THE HULK" TURNER. From 1972 to 1973 and 1975 to 1980, Parker MacDonald was general manager and head coach of the Nighthawks. He coached the 'Hawks to back-to-back Calder Cup Finals (1977–1978 and 1978–1979) and back-to-back Southern Division titles (1978–1979 and 1979–1980). He is pictured here talking to 'Hawks defenseman Dean Turner, one of the toughest Nighthawks of all time.

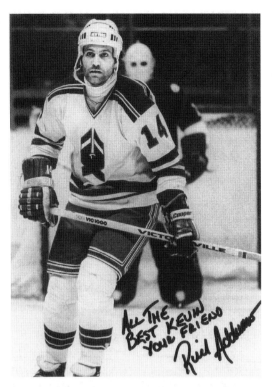

RICK ADDOUNO. In 1977–1978, while with Rochester, Rick Addouno led the AHL with 98 points. After a year in the WHA and another in the Central Hockey League (CHL), Addouno came to New Haven in 1980–1981. Nighthawks coach Rod Gilbert curiously deployed Addouno as the fourth line checking center, and he wound up tallying 6 goals, 12 assists, 18 points, and 57 PIM in 51 games. He played four NHL games with Boston (1975–1976) and Atlanta (1979–1980).

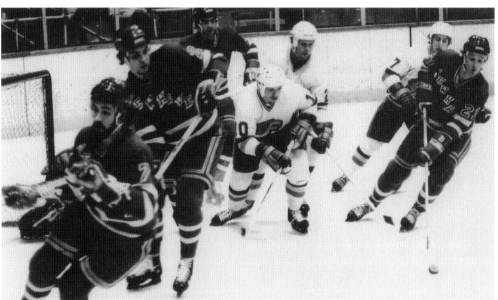

NEW HAVEN NIGHTHAWKS AT SYRACUSE FIREBIRDS. The Nighthawks are shown here at a road game in Syracuse from the 1979–1980 season. This was the first year under the new ownership of Joel Schiavone. The team colors were also changed to New York Rangers' red, white, and blue. Sporting the new jerseys with "New Haven" across the front are the Nighthawks' Jim Mayer, Andre Dore, and Larry Skinner (No. 21).

LET'S GO 'HAWKS

GLENN GOLDUP. Glenn Goldup is one of the last of the helmetless Nighthawks (Dan McCarthy and Rick Blight being the others). A veteran of 291 NHL games with Montreal and Los Angeles (1973–1981), Goldup brought his professionalism to the Nighthawks from 1981 to 1984. As a Nighthawk, Goldup played 95 games, scoring 47 points, 27 assists, while adding 166 PIM. He also served as player and assistant coach for head coach Nick Beverley.

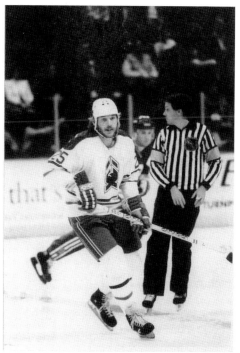

WARREN HOLMES. Forever etched in Nighthawks fans' memories for scoring the game-winning goal in the fourth overtime versus Rochester in Game 3 of the 1981–1982 first-round playoff series at the coliseum, is Warren Holmes. The game started on April 10 and ended on April 11. New Haven staved off elimination with that dramatic victory. Holmes scored 152 points, 81 assists and 80 PIM as a 'Hawk from 1981 to 1984.

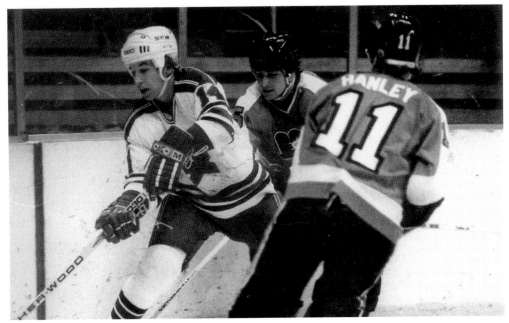

BROCK TREDWAY. This gifted right-winger out of Cornell University played four seasons for the Nighthawks (1981–1984 and 1985–1986), with a season in Austria (1984–1985) in between. Brock Tredway played 263 games with New Haven, tallying 171 points with 98 assists and 20 PIM. Tredway was an important part of the Nighthawks' 1982–1983 playoff run, in which he scored eight points in 12 playoff games.

BILLY O'DWYER. This Nighthawks captain was one of the most popular players in the team's history. Billy "O" played 293 games in New Haven (1982–1987 and 1990–1991), scoring 92 goals, 147 assists, 239 points, and 212 PIM. O'Dwyer played 120 NHL matches with the Los Angeles Kings (1983–1985) and the Boston Bruins (1987–1990).

PHIL SYKES. Phil Sykes is shown here at the coliseum after he scored the 100,000th goal in the history of the AHL on Sunday, December 11, 1983, against the Moncton Alpines. Dean Jenkins got the assist on the historic goal. A veteran of 456 NHL games, Sykes pinballed between Los Angeles and the Nighthawks for several years (1982–1990). He played 167 games for the 'Hawks, scoring 152 points, with 92 assists, while adding 277 PIM.

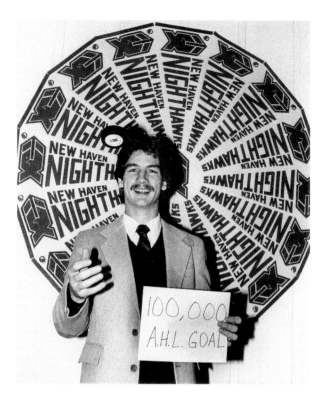

DARRYL EVANS. This high-scoring left-winger notched 51 goals for the Nighthawks during the 1983–1984 season. Darryl Evans scored 92 points in 66 games for the Binghamton Whalers (AHL) in 1985–1986. Evans spent all of the 1982–1983 season in the NHL with Los Angeles. In 169 games with the Nighthawks (1981–1985), he scored 87 goals, with 72 assists, 159 points, and added 36 PIM.

MARK LOFTHOUSE. Mark Lofthouse led the AHL in scoring in 1980–1981, with 48 goals, 55 assists, 103 points, and 131 PIM for the Hershey Bears. He appeared in 181 NHL games with Washington and Detroit (1977–1983), scoring 80 points with 42 goals. Lofthouse scored 101 points for the Nighthawks in 1983–1984. He played a total of 208 games for New Haven, tallying 98 goals, 130 assists, 228 points, and 139 PIM.

BLAINE STOUGHTON. Blaine Stoughton was a former 100-point and 50-goal scorer in a season, in both the WHA (Cincinnati, 1976–1977) and NHL (Hartford, 1979–1980). He scored a total of 449 points in 526 NHL games and 179 points in 219 WHA games before being assigned to the New Haven Nighthawks in 1984–1985 by the New York Rangers. In 60 games here, Blaine scored 45 points, with 25 assists and 35 PIM.

LET'S GO 'HAWKS

CARL MOKOSAK. Carl Mokosak spent the entire 1983–1984 season in New Haven and accumulated more than 300 PIM in five different seasons during his hockey career. In 80 games with the 'Hawks, he scored 18 goals, 21 assists, and 39 points, while racking up 206 PIM. He is pictured here devastating another opponent. His brother, John (Springfield, Adirondack), was well liked by the New Haven Veterans Memorial Coliseum's section 14 for his famous dancing when returning to the bench.

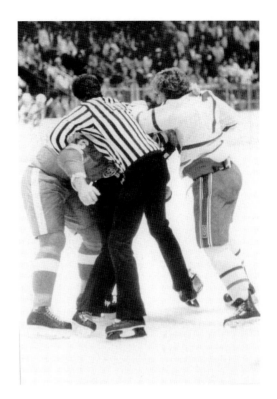

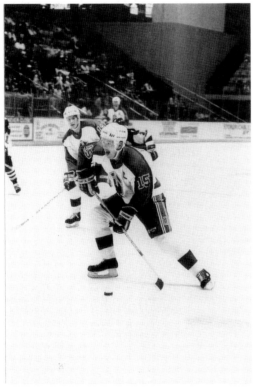

PAUL FENTON. Moved from the Whalers to the Rangers after the 1985–1986 season, Paul Fenton joined the Nighthawks for 1986–1987. In 70 games, he scored 37 goals, 38 assists, 75 points, and 45 PIM, and added 10 more points in seven playoff games. Fenton, now Los Angeles property, was called up to the Kings after scoring 11 goals in the Nighthawks' first five games of 1987–1988 and played five seasons in the NHL.

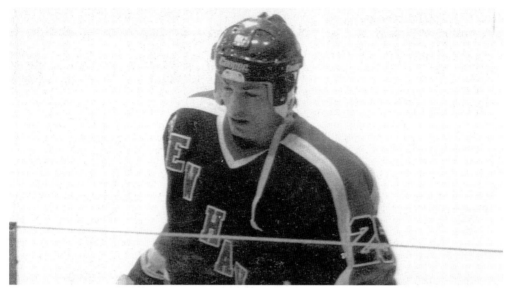

CHRIS MCSORLEY. A favorite of New Haven fans, Chris McSorley, the younger brother of former NHL policeman Marty McSorley, played parts of three seasons (1985–1988) for the Nighthawks, accumulating 314 PIM in 68 games. Chris's sometimes overambitious play resulted in his taking several ill-timed penalties, but his fans always supported him as the calls for "the McSorley line" echoed in the New Haven Veterans Memorial Coliseum.

KEN BAUMGARTNER. During the last 13 games of the 1986–1987 season, Nighthawks fans witnessed the greatest enforcer to ever play for a New Haven Veterans Memorial Coliseum team. After Ken "Boomer" Baumgartner fought, public address announcer Hal Baird was repeatedly requesting that the team doctor go to the visitors' locker room, as Baumgartner's opponents all required medical assistance. He amassed 306 PIM in 72 games with the 'Hawks (1986–1989) and 2,244 PIM in 696 NHL games (1987–2000).

LET'S GO 'HAWKS

JOHN ENGLISH. John "the Doctor" English performed many a fistic surgery on Nighthawks opponents between 1987 and 1989. In 117 games with New Haven, he scored 50 points, with 41 assists, while racking up 439 PIM. In 1989, after being sucker punched in Baltimore by Carl Mokosak, English was never quite the same. He and Brian Wilks were traded to Cape Breton for Jim Wiemer and Alan May late in the 1988–1989 season.

LANE LAMBERT. Right-winger Lane Lambert, a veteran of almost 300 NHL games, played 15 seasons of professional hockey. A very efficient two-way player, Lambert's career longevity was a testament to his overall execution of hockey fundamentals. This picture captures Lambert during his brief 11-game stint with the New Haven Nighthawks during the 1986–1987 season.

HOCKEY IN NEW HAVEN

ERIC GERMAIN. A steady, solid defenseman who always played his position well, Eric Germain played 183 games with the 'Hawks, including their 1988–1989 Calder Cup finalist team, scoring 34 points, 31 assists, and 287 PIM. Germain played four NHL games with Los Angeles in 1987–1988. In 2000–2001, he played seven games for the New Haven Knights (UHL) with one assist and 23 PIM.

GORDIE WALKER. Another very popular player for the 'Hawks, Gordie Walker was assigned to New Haven as both New York Rangers and later Los Angeles Kings property. Walker was an important part of the Nighthawks team that advanced to the 1989 Calder Cup Finals. In 203 games with New Haven, he scored 80 goals, 89 assists, 169 points, and 199 PIM. Walker appeared in 31 NHL games.

LET'S GO 'HAWKS

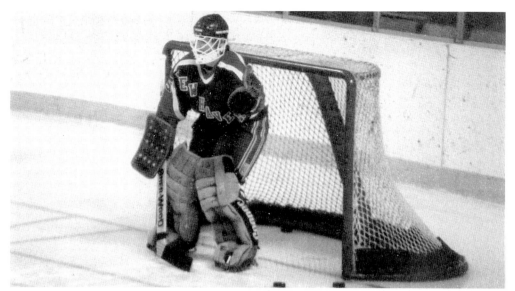

GLENN HEALY. Glenn Healy is pictured here during warm-ups with the Nighthawks. When Terry Kleisinger was unable to play, Healy took over in goal for the 'Hawks and never looked back. He played two seasons (1985–1987) with New Haven, compiling a record of 46-30-10. Healy played over 400 NHL games with the Kings, Islanders, Rangers, and Maple Leafs. Healy helped win the Stanley Cup in 1993–1994 with the New York Rangers.

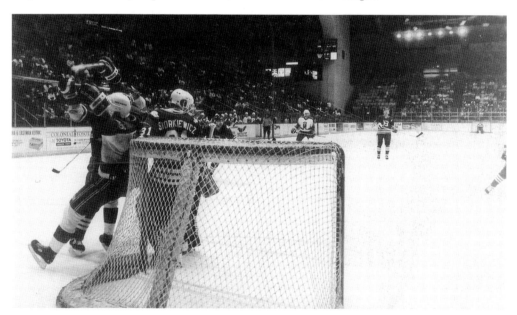

NEW HAVEN NIGHTHAWKS VERSUS BINGHAMTON WHALERS. This picture from the 1986–1987 first-round playoff series versus Binghamton shows a rocking crowd at the New Haven Veterans Memorial Coliseum. A loaded Nighthawks team featuring Dave Gagner, Mike Donnelly, Simon Wheeldon, Mark Lofthouse, Ron Scott, Glenn Healy, Terry Carkner, and others dropped a classic series to Binghamton, four games to three. Robbie Ftorek was head coach.

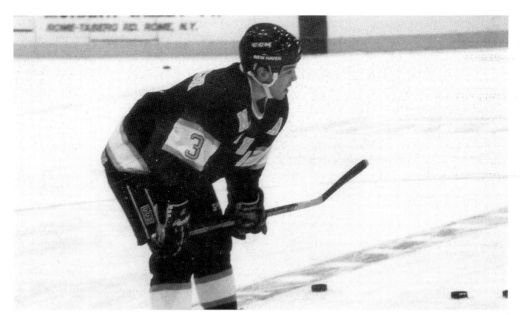

HUBIE MCDONOUGH. Hubie McDonough made quite a mark in his two seasons (1987–1989) with the Nighthawks before he would play in 195 NHL contests and then hundreds more in the IHL. McDonough was helping New Haven to the 1989 Calder Cup Finals. In 17 playoff games that year, he set a then AHL record with 31 points. McDonough scored 153 points and 84 assists in 152 games with the 'Hawks.

JOE DILL AND SON. Gary DeLeone is pictured with his father "Joe Dill" DeLeone. Between these two fine gentlemen, there is nearly 80 years combined experience in New Haven Arena and New Haven Veterans Memorial Coliseum concessions management. Joe Dill's association with the arena dates back to the 1930s. Joe was in charge of coliseum merchandising concessions until his passing in 1989. Gary was longtime food concessions manager at the coliseum until it closed in 2002.

LET'S GO 'HAWKS

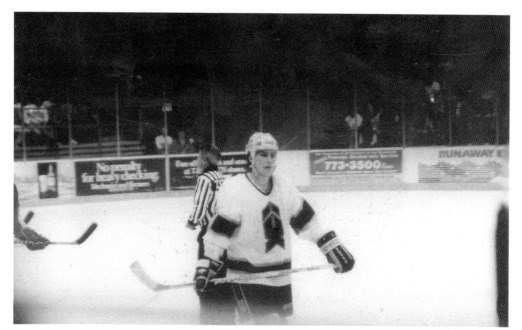

ALAN MAY. Alan May arrived in New Haven with Jim Wiemer near the end of the 1988–1989 season in the trade that sent John English and Brian Wilks to Cape Breton. May's regular-season contribution was 10 points in 12 games, along with 99 PIM. He added six goals and 105 PIM in 16 playoff games during the 'Hawks' run to the 1989 finals.

DAVE PASIN. The most remembered Nighthawks moment of all is Game 4 of the 1989 first-round playoff series at the coliseum versus Sherbrooke. The Nighthawks trailed by a goal with three seconds left, when the Canadiens' Luc Gaithier knocked his net off its moorings. Referee Paul Devorski awarded the Nighthawks a penalty shot, and Dave Pasin cashed it in, the 'Hawks won in overtime and eventually advanced to the finals.

CRAIG DUNCANSON. A veteran of 12 professional seasons in the IHL, AHL, and NHL, from 1985 to 1997, Craig Duncanson's physical style of play made him a favorite of the New Haven Veterans Memorial Coliseum faithful. Over the course of three seasons with the Nighthawks (1987–1990), Duncanson played 177 games, scoring 57 goals, 94 assists, 151 points, and posted 522 PIM. He was the consummate teammate and a Nighthawks captain.

PAT HICKEY, JOHN TORTORELLA, AND RICK DUDLEY. President and general manager Pat Hickey ran a top-notch front office that worked closely with the parent Los Angeles Kings. Head coach Rick Dudley and associate coach John Tortorella lead the 35-35-10 fourth-place Nighthawks past powerhouse Sherbrooke and tough Moncton all the way to the finals versus the Adirondack Red Wings, who stopped the Cinderella 'Hawks four games to one.

LET'S GO 'HAWKS

STEVE RICHMOND. Steve Richmond was a physical defenseman who appeared in 159 NHL games with the Rangers, Red Wings, Devils, and Kings between 1983 and 1989. Richmond played for the Nighthawks during 1984–1986 and in 1988–1989 and was the emotional leader of the New Haven squad on its way to the 1989 Calder Cup Finals. As a Nighthawk, Richmond scored 62 points on 52 assists with 268 PIM in 97 games.

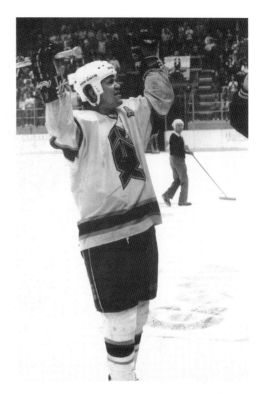

ROLLIE MELANSON. A three-time Stanley Cup champion with the New York Islanders (1980–1981, 1981–1982, and 1982–1983), Rollie Melanson was sent down to New Haven in 1989 after Los Angeles acquired Kelly Hrudey from the Islanders. Melanson backstopped the Nighthawks all the way to the 1989 Calder Cup Finals, starting all 17 games for the 'Hawks, who ultimately fell to the Adirondack Red Wings four games to one.

BOB JANECYK. Bob Janecyk shared the Harry "Hap" Holmes award (fewest goals allowed) with teammate Warren Skorodenski en route to the 1981–1982 Calder Cup championship with the New Brunswick Hawks. A veteran of 110 NHL games, Janecyk played 71 games with New Haven (1987–1989), with a record of 33-26-9. Janecyk abruptly quit hockey on the eve of the 1989 playoffs, leaving Nighthawks fans to wonder, "what if?"

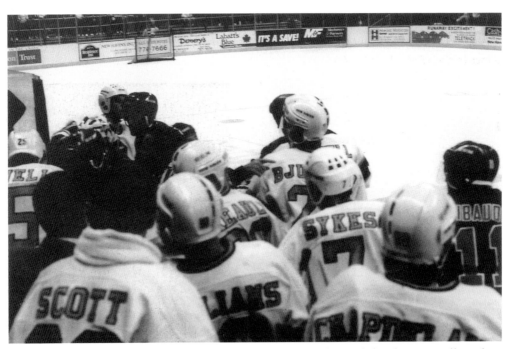

SPRINGFIELD'S TODD EWEN VISITS NIGHTHAWKS BENCH. The Nighthawks were well on their way to a 13-3 victory over their archrival, the Springfield Indians. Todd Ewen of the Indians dove into the 'Hawks bench, setting off what would be a series of scrums that were littered throughout this 1989–1990 contest at the New Haven Veterans Memorial Coliseum. Nighthawks versus Indians games were always entertaining and hard-fought matches.

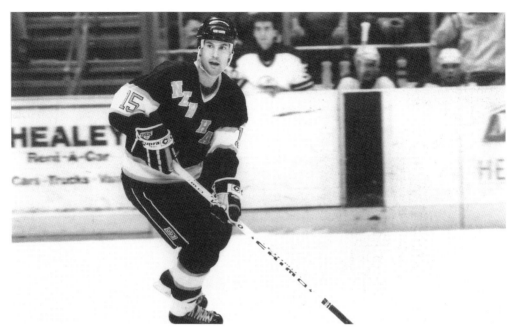

CHRIS KONTOS. Pictured here sporting the black New Haven road jersey during a reverse jersey night game at the coliseum in 1989–1990 is Chris Kontos. He played 173 games for the Nighthawks (1984–1988 and 1989–1990), scoring 151 points, 92 assists, and 101 PIM. He played 203 NHL games, scoring 123 points, once scoring nine goals in 11 games for the Los Angeles Kings in the 1989 NHL playoffs.

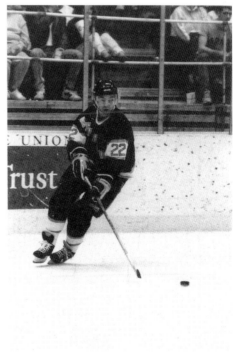

NICK FOTIU. One of the most popular players in New York Rangers history, Nick Fotiu made several stops in New Haven: five games in 1977–1978, nine games in 1985–1986, and 31 games as player and associate coach of the Nighthawks in 1989–1990. The extremely tough Fotiu scored 11 points and added 70 PIM in 45 games in New Haven.

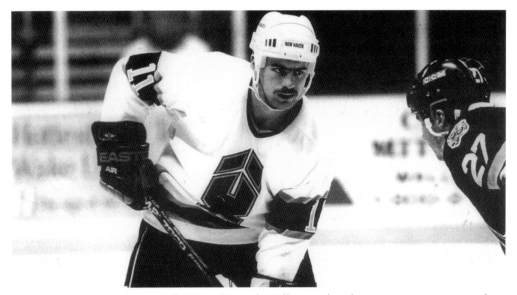

DARRYL WILLIAMS. Feisty left-winger Darryl Williams played an in-your-opponent's-face, aggressive style that won the hearts of the Nighthawks' faithful. Although injuries kept him out of the New Haven lineup for various stretches of time, it did not dampen his aggressive play, as his 445 PIM in 136 games with the 'Hawks would attest. Williams added 59 points on 28 goals and 31 assists while in New Haven (1988–1992).

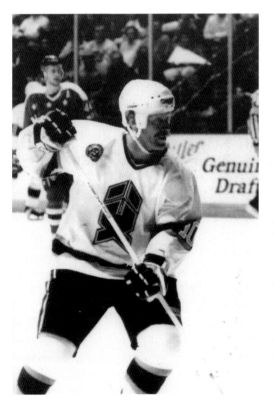

JOHN ANDERSON. Peter Shipman operated the 1991–1992 Nighthawks as an independent, the last AHL team to ever do so. One of Shipman's best moves that season was signing John Anderson as a free agent. In 68 games, Anderson scored 41 goals, 54 assists, 95 points, and 24 PIM en route to being named AHL MVP and also winning the Fred T. Hunt Memorial Award for sportsmanship. A late-season injury hampered Anderson in the playoffs.

LET'S GO 'HAWKS

SENATE HEARINGS

NEW HAVEN SENATORS HOCKEY ARRIVES. Pictured from left to right are Kevin Tennyson (WWCO AM 1240), New Haven Senators owner Peter Shipman, and Walt Mann (WWCO AM 1240) in the Senators locker room. After operating the Nighthawks as an independent club in 1991–1992, Shipman signed a three-year affiliation deal with the expansion Ottawa Senators of the NHL. The New Haven Nighthawks then became the New Haven Senators. The name change never sat well with many fans. Add to that an increase in ticket prices, along with a very young inexperienced team on the ice, and it was a recipe for disaster. The Senators drew poorly in New Haven, averaging 1,926 fans per game. Shipman sold the club to parent Ottawa in February 1993, and attendance dropped precipitously from that time forward. The Senators finished their only campaign at the New Haven Veterans Memorial Coliseum in last place with a dismal record of 22-47-11.

NEW HAVEN HOCKEY MEMORABILIA AT OPENING NIGHT. Although the team name was changed from Nighthawks to Senators, owner Peter Shipman tried to tie the Senators into New Haven hockey tradition by displaying memorabilia from the Elm City's past professional teams. Pictured here are some items that were on display at the New Haven Veterans Memorial Coliseum for this special night. Notice the New Haven Blades jacket hanging to the left of this display.

MARK LaFOREST. Although rookie goaltender Darrin Madeley was to be the future of the Ottawa Senators between the pipes, when the New Haven Senators were making a push for the Calder Cup playoffs, Shipman insisted veteran Mark LaForest start in goal. LaForest performed as best he could, with a very porous defense in front of him. A late-season loss in Providence eliminated New Haven from the playoff race.

SENATE HEARINGS

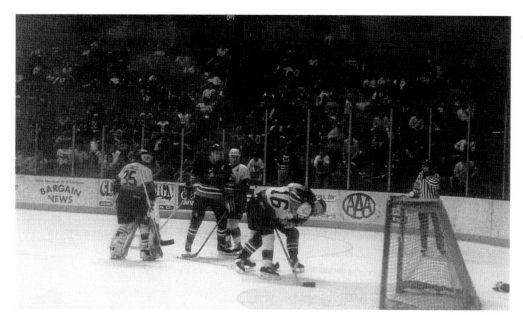

GREG PANKEWICZ. Gritty winger Greg Pankewicz, pictured here in action during the New Haven Senators' final game at the coliseum, was one of the brighter lights on an otherwise low-voltage team. He played 62 games for New Haven, netting 23 goals and 20 assists, totaling 43 points. The always-aggressive Pankewicz added 163 PIM. As of this writing, Pankewicz was playing in his 16th pro season.

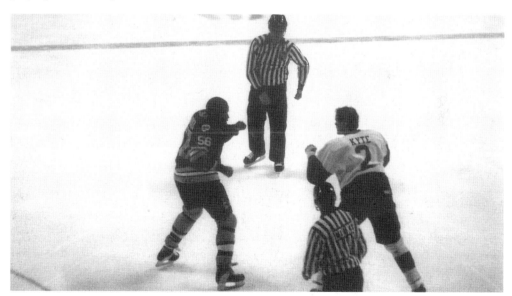

JIM KYTE. Jim Kyte was an NHL veteran with more than 500 NHL games to his credit when the NHL expansion Ottawa Senators sent him to their AHL affiliate in New Haven to help stabilize an extremely young roster. Kyte skated in 63 games for New Haven, without any doubt the team's best defenseman. He scored six goals and added 18 helpers for 24 points to go along with 163 PIM.

BOB DEMATTEO. Longtime New Haven Veterans Memorial Coliseum usher Bob DeMatteo poses at his post during one of the final games of the New Haven Senators' season. DeMatteo worked at the coliseum from 1975 to its closing in 2002 and was one of the many long-tenured persons who always made any event at the coliseum an enjoyable experience for patrons.

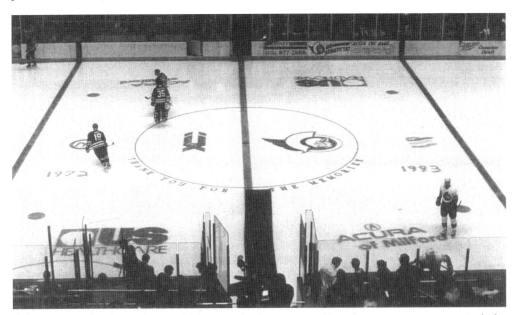

THANKS FOR THE MEMORIES. This photograph captures the coliseum center ice artwork for the Senators' final home game. "Thanks for the Memories," along with a Nighthawks logo on the left and a Senators logo on the right, tells a bittersweet story of 21 seasons of hockey at 275 South Orange Street that was coming to a close. No one knew if the coliseum would have another chance at hockey again.

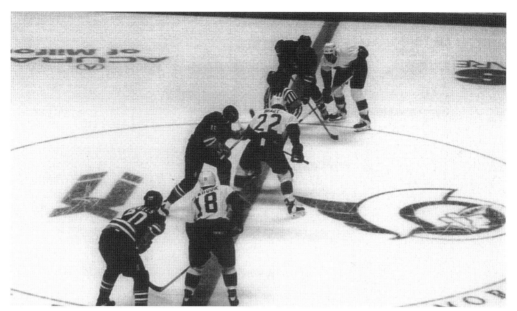

FINAL OPENING FACE-OFF. Neil Brady takes the opening face-off for the New Haven Senators to start their final game at the New Haven Veterans Memorial Coliseum on April 9, 1993, versus the Springfield Indians. The largest crowd of the season, 4,613, turned out to witness the Indians defeat the Senators 7-5. New Haven would travel to Springfield the following night to finish out their one dismal season in the Elm City.

"WHERE WERE ALL OF YOU THIS YEAR?" This sign swept up in a pile of trash after the Senators final game at the coliseum, April 9, 1993, says it all. Unfortunately for the loyal New Haven fans, the extra 2,500 or so who were on hand for this game evidently failed to show up for the Senators' other 39 home games, thus forcing owner Peter Shipman's hand to sell the team.

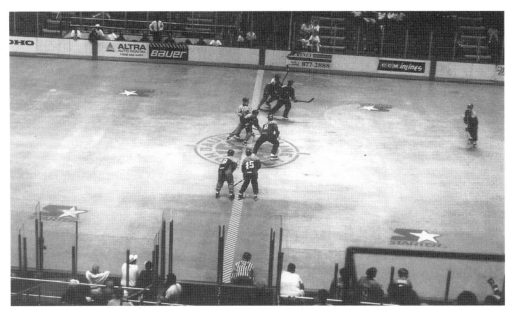

ROLLER HOCKEY AT THE COLISEUM. Shortly after the New Haven Senators left town following the 1992–1993 AHL season, a professional roller hockey team was placed in the New Haven Veterans Memorial Coliseum. The year 1993 was the inaugural season for Roller Hockey International (RHI). The Connecticut Coasters, co-owned by the RHI and the coliseum, featured several area players on their roster, including Berkley Hoagland, T. J. Shatz, and Todd Johnson.

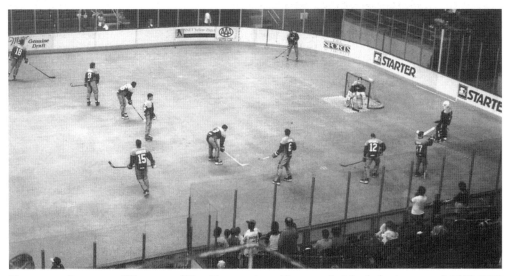

COASTERS PREGAME WARM-UP. The Connecticut Coasters finished the inaugural 1993 RHI season with a record of 7-5-2. The Coasters were defeated in the first round of the RHI playoffs by a score of 15-8 by the eventual 1993 RHI champion Anaheim Bullfrogs. The Connecticut franchise was moved to California for the 1994 RHI season, where they were renamed the Sacramento River Rats.

Unleash the Beast

David Gregory. Pictured here is Beast of New Haven president and general manager David Gregory. After the coliseum was dark for hockey for four years, Paragon Sports leased the Carolina Monarchs AHL franchise and moved it to New Haven. The Monarchs had lost their home ice to the transplanted Hartford Whalers (currently the Carolina Hurricanes) of the NHL. The Beast was affiliated with both the Carolina Hurricanes and the Florida Panthers of the NHL. The Beast had one of the more talented rosters during their time in the AHL (1997–1999). Kevin McCarthy was head coach, and he was assisted by Joe Paterson. The Beast two-year record was 71-68-14-5 and included one playoff appearance in which the Beast were swept 3-0 in the first round by the Hartford Wolfpack.

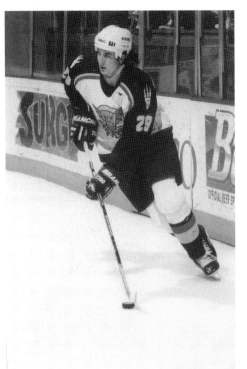

FILIP KUBA. Filip Kuba has appeared in over 400 games in the NHL. In 1997–1998, Kuba played 77 games, scoring 4 goals and 13 assists for 17 points, along with 58 PIM for the Beast of New Haven. In 2000–2001, he spent the entire season in the NHL with the Minnesota Wild, and he has not returned to the minors since. He played for the Tampa Bay Lightning in 2006–2007.

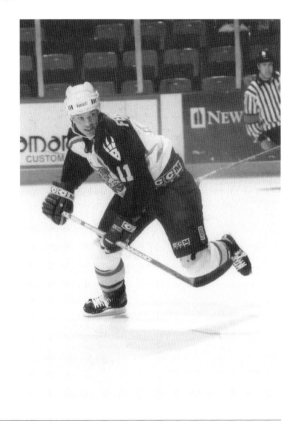

CRAIG FERGUSON. A seventh-round draft pick of the Montreal Canadiens in 1989, Craig Ferguson appeared in 13 games in the NHL for Montreal and became a Florida Panther in 1996. Ferguson was assigned to Florida's top affiliate in 1997–1998, the Beast of New Haven, and went on to play 125 games for New Haven from 1997 to 1999. He scored 97 points during his tenure with the Beast.

UNLEASH THE BEAST

BYRON RITCHIE. Scrappy center Byron Ritchie was an important part of both seasons of Beast of New Haven hockey. In 129 games with the Beast, Ritchie netted 37 goals and 51 assists for 88 points along with 236 PIM. After the Beast, he spent six out of the next seven seasons playing mostly in the NHL.

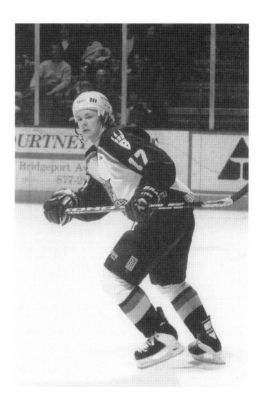

JOHN JAKOPIN. An imposing figure at six feet, four inches, and 235 pounds, John Jakopin was a steady, stay-at-home defenseman for the Beast of New Haven. The recipient of the inaugural Yanick Dupre Memorial Award for outstanding community relations in 1997–1998, Jakopin played 120 games in New Haven, scoring 4 goals and 25 assists for 29 points to go along with a two-year total of 305 PIM.

MIKE FOUNTAIN. Mike Fountain played 101 games over two seasons as the top goaltender of the Beast. Some New Haven fans feel that Fountain's recall to the Carolina Hurricanes (NHL) just in time to miss the Beast first-round playoff series against the Hartford Wolf Pack was a major contributing factor in the Beast being swept out of the 1997–1998 Calder Cup first-round series three games to none.

HERBERT VASILJEVS. With 36 goals and 30 assists for 66 points, Herbert Vasiljevs was the third-leading scorer for the Beast of New Haven in their inaugural 1997–1998 season. The following year the Florida Panthers sent some of their top prospects to the Kentucky Thoroughblades of the AHL, where Vasiljevs totaled 76 points. He appeared in over 400 professional games in his career and also played three seasons in Europe.

BEAST FACE-OFF. This picture captures the Beast of New Haven starting another game during their 1997–1998 inaugural season at the renovated and brightened New Haven Veterans Memorial Coliseum. The Elm City seemed to embrace its newest entry into the AHL. With the Hartford Wolfpack, also a new entry into the AHL, that gave New Haven its closest geographical rival ever.

PETER WORRELL. Opposing AHL players from 1997–1999 always kept an eye open for Beast forward Peter Worrell when they skated against New Haven. While racking up 374 PIM in 60 games, Worrell was a force to be reckoned with as chief policeman on the Beast. He tallied 31 points with New Haven. He went on to play in almost 400 games in the NHL, piling up 1,554 PIM.

HOCKEY IN NEW HAVEN

TOM COLLEY NIGHT WITH THE BEAST. On March 14, 1998, due in part to the perseverance of New Haven Traveling Sports Club president Gary Mattei, Tom Colley's No. 9 was once again raised to the rafters of the New Haven Veterans Memorial Coliseum. The No. 9 was never worn by a Beast player, as the new franchise respected the retirement of Colley's No. 9 of the New Haven Nighthawks.

JENNIFER ANDREOZZI SINGS THE NATIONAL ANTHEM. The Beast of New Haven interacted very closely with their fan base. Many times a Beast fan was given the opportunity to sing the national anthem before the game. Seven-year-old Jennifer Andreozzi is shown singing "The Star Spangled Banner" as the Beast of New Haven are sporting their special green St. Patrick's Day jerseys at the New Haven Veterans Memorial Coliseum.

CHAD CABANA. In 1997–1998, in only 34 games, Chad Cabana was second on the Beast with 163 PIM and 19 fights. In 1998–1999, Cabana played 66 games and racked up 251 PIM for a two-year Beast total of 414 penalty minutes in 100 games. He returned to New Haven for the 2000–2001 season to play with the Knights (UHL), adding 207 PIM in 51 games.

TODD MACDONALD. Todd MacDonald joined the Beast of New Haven during the latter stages of the 1997–1998 season. MacDonald started all three playoff games versus Hartford. He was with the Beast for the entire 1998–1999 season. His totals with New Haven were 18 wins, 19 losses, and 5 ties. Todd played six seasons of professional hockey.

JOEY TETARENKO. The Beast of New Haven not only were a good skating club, they also had several physical players as well. Six-foot-two-inch, 230-pound defenseman Joey Tetarenko was one of New Haven's more physical players. As a rookie in 1998–1999, he appeared in 65 games for the Beast and was a solid defenseman who scored 14 points and added 154 PIM.

NEW HAVEN POLICE ATHLETIC LEAGUE. One of the local community's entities that were highly visible at the Beast games was the New Haven Police Athletic League, promoting playgrounds not prisons. Pictured here from left to right are Beast master of ceremony Mike Caprio, New Haven police sergeant Pat Redding, New Haven police officer Frank Murphy, and Beast president and general manager David Gregory.

UNLEASH THE BEAST

SHANE WILLIS. As the 1998–1999 AHL Dudley "Red" Garrett Memorial Award (outstanding rookie) winner, Shane Willis thrilled the New Haven Veterans Memorial Coliseum fans each and every time he took a shift for the Beast. Willis scored 31 goals and added 51 assists for 82 points in 74 games. He played over 450 professional games during his career, including 174 games played in the NHL.

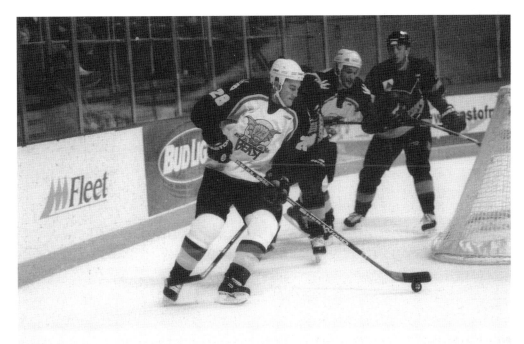

DWAYNE HAY. "Hay, Hay, Hay," rang out around the coliseum every time energetic left-winger Dwayne Hay hit the ice for the Beast. Constant hustle is what New Haven received as Hay totaled 21 goals and 19 assists for 40 points in 56 games for the Beast of New Haven (1997–1999). Hay spent parts of the three following seasons in the NHL with Florida, Tampa Bay, and Calgary.

SCOTT LEVINS. Scott Levins provided the Beast with a physical two-way veteran, and the Hurricanes a player they would have no hesitation in calling up during the season. The rugged Levins played all 80 games for the Beast, tallying 32 goals, 26 assists, 58 points, and 189 PIM (1998–1999). Levins played professional hockey for five more seasons and finished his long career, which included 124 NHL games, in the UHL (2003–2004).

FULL HOUSE AT BEAST GAME. Beast of New Haven mascot Buddy the Beast says hello to some of the 7,000-plus fans at this Beast game at the New Haven Veterans Memorial Coliseum. The Beast averaged 4,400 fans per game during their two-year stint in the Elm City. This is relatively comparable to what the Bridgeport Sound Tigers (AHL) draw at the brand-new and sparkling Arena at Harbor Yard.

UNLEASH THE BEAST

KNIGHT TIME FUN

NEW HAVEN KNIGHTS OWNERS. Pictured are the men who brought New Haven its final chance at professional hockey. In the center is majority owner Dr. Eric Margenau. The local minority owners are, from left to right, Mark DiLungo, Len Fasano, Pasquale DiLungo, Alphonse Paolillo, Louis DeMaio, and Louis Pane. These men were responsible for bringing New Haven two more years of hockey. Knights fans will always be grateful to these men. The Knights made the UHL Colonial Cup playoffs both years, advancing to the second round in 2000–2001, and were swept in the first round in 2001–2002. The Knights set a UHL expansion club record at 41 wins and 89 points in 2000–2001.

JIM BROWN. A former 50-goal scorer (120 points) in 1995–1996 with the Knoxville Cherokees of the East Coast Hockey League (ECHL), center Jim Brown was another fine player on the strong 2000–2001 New Haven Knights squad. Brown was an integral part of the Knights' special teams, and his totals of 35 goals and 44 assists for 79 points in 70 games were outstanding. He played three more years of hockey after 2000–2001 before retiring.

MIKE POMICHTER. North Haven native Mike Pomichter skated in over 500 professional games in his career. In October 2000, he was named captain of the Knights (UHL) for their inaugural season. Pomichter played 129 games over two seasons (2000–2002) for the Knights, scoring a total of 102 points, while having the privilege of performing in front of his family and friends at the New Haven Veterans Memorial Coliseum.

KNIGHT TIME FUN

MIKE MELAS. Although an injury caused him to miss half of the 2000–2001 UHL season, Mike Melas was an asset when he finally was able to take the ice for the New Haven Knights. In addition to his gritty, consistent two-way play, Melas scored 42 points in 43 games. He added six more points in the Knights' seven playoff games to finish off a fine season in New Haven.

BLAIR ALLISON. The backbone of the New Haven Knights' inaugural season, Blair Allison played 50 games in goal, posting a 29-13-6 record with a 2.63 GAA. Allison played four more seasons after his one year in New Haven to round out his nine seasons in professional hockey. Allison was the recipient of the 2000–2001 Section 14 Impact Player of the Year Award.

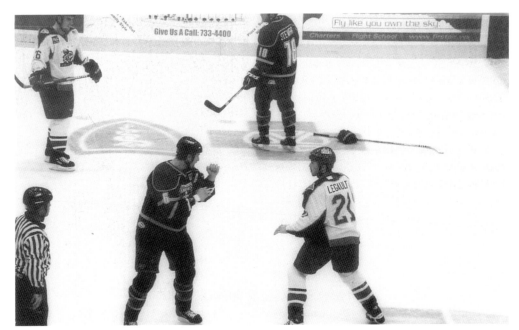

KENZIE HOMER. "Homer, Homer," was the chant every time this New Haven favorite took the ice at the coliseum. Six-foot-four-inch, 225-pound Kenzie Homer was a physical player who earned the fans' support with his outstanding effort, game in, game out. The recipient of the 2001–2002 Section 14 Impact Player of the Year Award played both Knights seasons in New Haven, totaling 51 points and 396 PIM in 142 games.

NICK THE KNIGHT IN SECTION 14. During the inaugural Knights game at the New Haven Veterans Memorial Coliseum, team mascot Nick the Knight cavorts with the fans in section 14. Nick the Knight was very popular with the fans, particularly the kids. Nick could be found on game nights all around the coliseum, and he led fans in cheering on their New Haven Knights each and every game.

KNIGHT TIME FUN

PHIL ESPOSITO. Rugged Phil Esposito played left wing for the New Haven Knights (UHL) during their inaugural 2000–2001 season at the New Haven Veterans Memorial Coliseum. Esposito also had the distinction of being the first New Haven Knight to drop the gloves in front of the coliseum faithful. Esposito accumulated 1,037 PIM while playing nine seasons of professional hockey, finishing with the New England Stars (NEHL) in 2006–2007.

JOHN VECCHIARELLI. This veteran forward of many professional seasons had tallied 54 points in 45 games for the 2000–2001 Knights before leaving the team to play in Europe. "Uncle Veck" was a highly skilled face-off man for the Knights and also has the distinction of being the last New Haven professional hockey player to wear the classic Jofa helmet during game action on the road and at the coliseum.

ANGELO MAZELLA. Shown holding up the section 14 St. Patrick's Day jersey at the jersey auction, Angelo Mazella was thrown right into the fire when general manager Chris Presson suddenly resigned early in the 2000–2001 season. Mazella made the jump from assistant general manager to general manager. With several different promotions, such as "guaranteed win knight," Mazella was successful in raising attendance at Knights games during the second half of the first season.

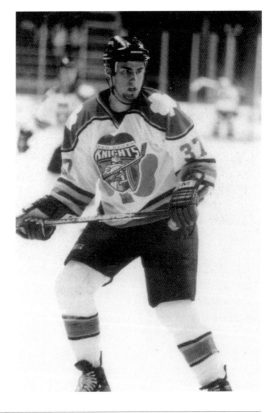

NICK LENT. A checking forward on the 2000–2001 Knights, Nick Lent only appeared in 26 games for New Haven due to injury. However, Lent scored one of the most important goals in New Haven's history when his first-round playoff tally versus Adirondack helped the Knights stave off elimination and sent the New Haven Veterans Memorial Coliseum crowd into a frenzy, and the Knights along their way to an eventual three-games-to-two series victory.

KNIGHT TIME FUN

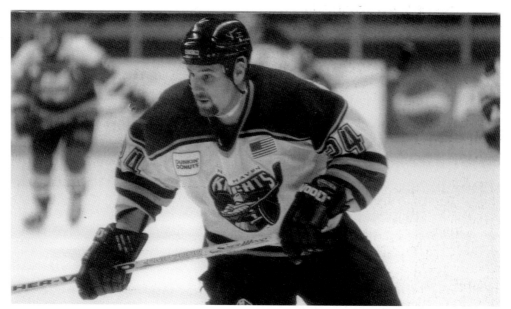

HOWIE ROSENBLATT. Howie Rosenblatt had been retired for two seasons when he joined the Knights in the latter stages of the 2001–2002 season. Rosenblatt had last played in 1998–1999. "The Legend" was up to the task, scoring four goals and adding five assists for nine points in 12 games, as well as several displays of his fighting prowess, while helping the Knights to a second UHL playoff appearance.

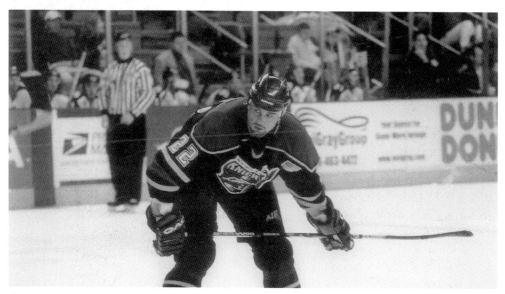

GARRETT BURNETT. Garrett Burnett was slated to start the 2001–2002 season with the Knights. He was called up to the AHL by the Cincinnati Mighty Ducks and only appeared in four games with the Knights, accumulating 40 PIM, along with a suspension by the UHL. After playing 2003–2004 in the NHL with Anaheim, Burnett was a player and assistant coach for the Danbury Trashers (UHL) in 2004–2005.

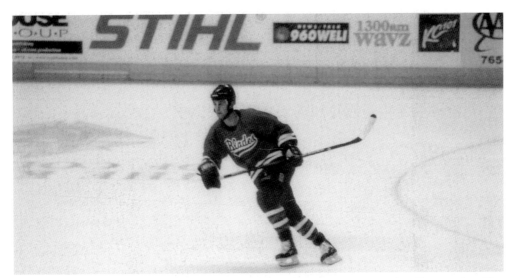

KEN BOONE. A total of 318 penalty minutes in only 43 games pretty much tells one what Ken Boone's role was on the 2001–2002 Knights. Boone rang up over 300 PIM in each of his previous three professional seasons. New Haven fans figured out rather quickly that Boone would fight anyone and everyone. He played three more professional seasons. Boone is pictured wearing the "turn back the clock" Blades jersey for the Knights.

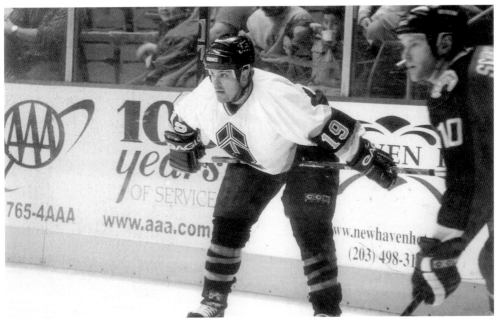

CHRIS CERRELLA. Chris Cerrella was arguably one of the most popular favorites of the ladies since Dean DeFazio played for the Nighthawks in 1987–1988. In 2001–2002, Cerrella joined the Knights, where he tallied 27 points in 48 games. He is one of the players honored by Quinnipiac University for scoring over 100 career points. He is pictured wearing the "turn back the clock" Nighthawks jersey for the Knights.

SECTION 14 FULL OF KNIGHTS FANS. The New Haven Veterans Memorial Coliseum's notorious section 14 was very involved in Knights games. Although several of the "regulars" from the Nighthawks games never surfaced for the UHL action, those who sat in this area adjacent to the visitors bench became well known around the circuit for stirring up the Knights' opposition on a nightly basis. Section 14 always strived to give the home team the advantage.

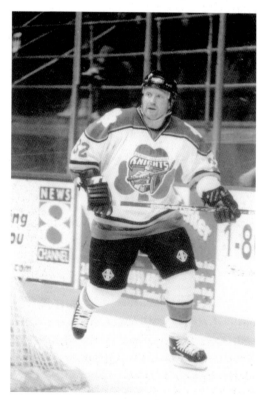

GLENN STEWART. Glenn Stewart played 107 games for the New Haven Knights, scoring 58 goals and 84 assists for 142 points in his one and a half seasons in New Haven. Stewart added 10 more points for the Knights in 11 playoff games. With his laserlike slap shot, Stewart tallied more than 700 points in his nine-year professional hockey career, in the AHL, IHL, ECHL, UHL, and the West Coast Hockey League (WCHL).

PAUL GILLIS AND DAVE HAINSWORTH. Knights head coach Paul Gillis (right) and goaltending coach Dave Hainsworth are captured in this candid shot, watching the warm-ups from their perch at the New Haven Veterans Memorial Coliseum in section 7. Gillis led the Knights to the UHL playoffs both seasons and won the 1997–1998 Colonial Cup as head coach of the Quad City Mallards. He also coached the 2005–2006 Danbury Trashers to the UHL finals.

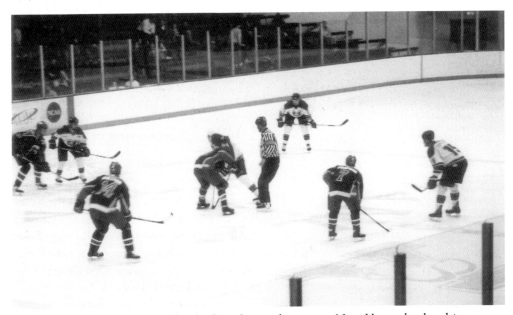

FINAL NEW HAVEN GAME. The final professional game in New Haven hockey history was played at Yale's David S. Ingalls Rink, due to a scheduling conflict at the coliseum. The Elmira Jackals won Game 3 of their first-round Colonial Cup playoff series 5-2, to sweep the best of five series three games to none and send Knights fans home wondering if professional hockey in New Haven would continue. It would not.

KNIGHT TIME FUN

8

THE BAD BOYS
OF HOCKEY

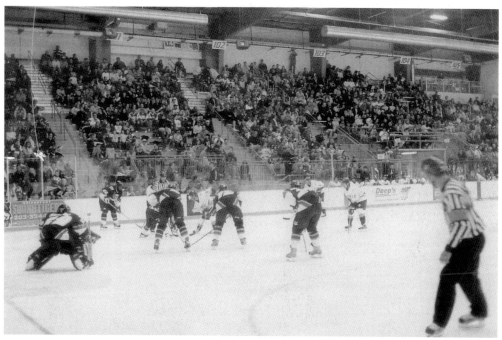

DANBURY TRASHERS HOCKEY. After the 2001–2002 season, New Haven Knights majority owner Dr. Eric Margenau opted not to exercise his lease option in time for a third year of play in the New Haven Veterans Memorial Coliseum. Shortly thereafter, New Haven mayor John DeStefano Jr. stated that an independent feasibility study would determine whether or not the City of New Haven would continue to operate the coliseum. Enter Danbury businessman James Galante. Galante attempted to purchase the New Haven Knights, but the deal did not come to fruition due in part to the fact that he was unable to secure ice time at the coliseum since the venue was now slated to be shuttered and ultimately demolished. Fast-forward to 2004 when Galante purchased a UHL expansion franchise, the Danbury Trashers, and named his son A. J. Galante as team president. Many New Haven fans made the two-hour round trip over the next two seasons (2004–2006) to support the toughest and most entertaining team in UHL history.

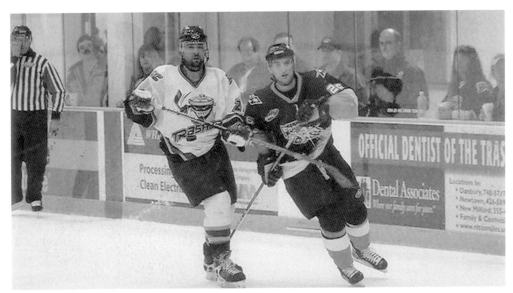

FRANK "THE ANIMAL" BIALOWAS. Menacing forward Frank "the Animal" Bialowas was brought in by Trashers management for special occasions, such as home games against the physical Flint Generals and Danbury's archrival, the Adirondack Frostbite. Bialowas played six games for the Trashers from 2004 to 2006, striking fear into Trasher opponents while racking up 78 PIM. He won a Calder Cup with the Philadelphia Phantoms (1997–1998) and was inducted into the Hockey Hall of Fame in 2005.

BRAD WINGFIELD. On a team with many tough guys and fighters, Brad "Winger" Wingfield was front and center as the Trashers' top enforcer. Wingfield had set the UHL single-season record with 576 PIM while with Elmira in 2002–2003. In two seasons with Danbury, Wingfield rang up 496 PIM in 56 games from 2004 to 2006 and has a career total of 3,303 PIM during his 11-year professional career.

THE BAD BOYS OF HOCKEY

JON "NASTY" MIRASTY. Although most of his fistic opponents were bigger than him, Jon "Nasty" Mirasty more than held his own during these encounters. Mirasty may have the fastest hands since Ken Baumgartner's heyday. Always ready to protect his teammates, he always fought with a smile. He played 36 games for Danbury (2004–2006) and amassed 259 PIM. Mirasty has 1,406 PIM so far in his professional career.

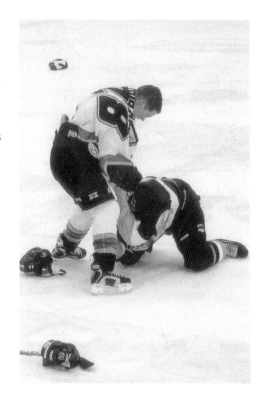

DAVE MACISAAC. Dave MacIsaac is a veteran of almost 400 AHL games, including winning the Calder Cup with the Philadelphia Phantoms in 1997–1998 as a teammate of future Danbury Trashers forward Frank Bialowas. MacIsaac played 62 games for Danbury (2004–2006), scoring 42 points, 16 goals, and 196 PIM. He played a major role in helping the Trashers reach the 2005–2006 UHL Colonial Cup Finals.

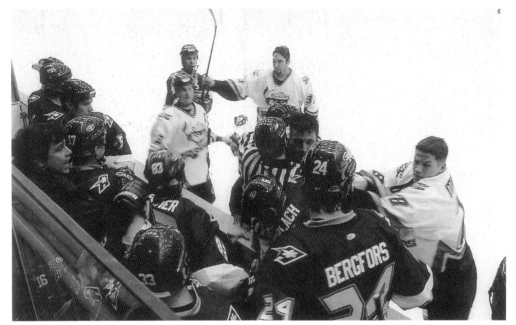

FIGHT AT VISITORS' BENCH. The Adirondack Frostbite quickly became the Trashers' biggest rival. Games between these two teams were very intense. During the game pictured here, Danbury's Chad Wagner, Gerry Hickey, Jon Mirasty, Bruce Richardson, and Dave MacIsaac challenge Marc Potvin's bench. Wagner would be banned for life from the UHL, MacIsaac for the rest of the season; Mirasty and Hickey were each given 10-game suspensions because of this melee.

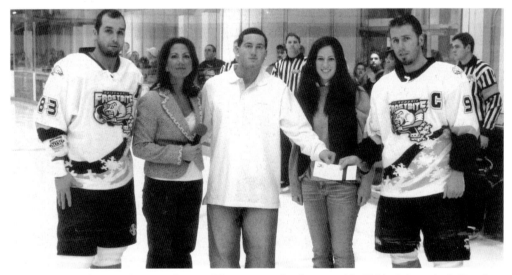

THE HOCKEY FAMILY ALWAYS STICKS TOGETHER. On January 13, 2006, Adirondack Frostbite head coach Marc Potvin was found dead in his hotel room. In the wake of this tragedy, the Trashers' owner James Galante and his family donated $10,000 to the Potvin family. Pictured are Roseanne Galante, A. J. Galante, and Candace Galante, along with Sylvain Cloutier and Hugo Belanger of the Frostbite. Section 102 made a donation as well.

THE BAD BOYS OF HOCKEY

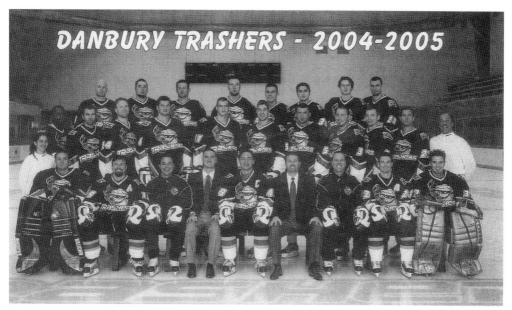

DANBURY TRASHERS, 2004–2005. Pictured here are Scott Stirling, Jim Duhart, Bob Stearns, team president A. J. Galante, captain Brent Gretzky, team owner James Galante, head coach Todd Stirling, Bruce Richardson, Guillame Lavallee, trainer Rachel Schneidermen, Rumon Ndur, John Morlang, Doug Christiansen, Jeff State, Ivan Curic, Mario Larocque, Garrett Burnett, Nicholas Bilotto, P. J. Byrne, Brian Hebert, Tommy Pomposello Jr., Gerry Hickey, Brad Wingfield, Alex Goupil, Ray Williams, J. F. David, and Samir Ben-Amour.

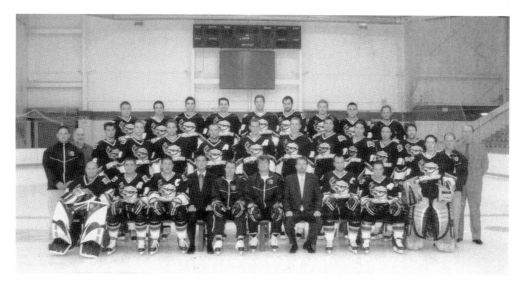

DANBURY TRASHERS, 2005–2006. The second year, the Trashers were coached by former New Haven Knights head coach Paul Gillis. New additions Jamie Thompson, Sylvain Daigle, David Hymovitz, David Beauregard, Shawn Colleymore, and J. M. Daoust helped the Trashers improve their regular season wins by four, and points by eight. The Trashers advanced all the way to the UHL Colonial Cup Finals, where they lost to Kalamazoo four games to one.

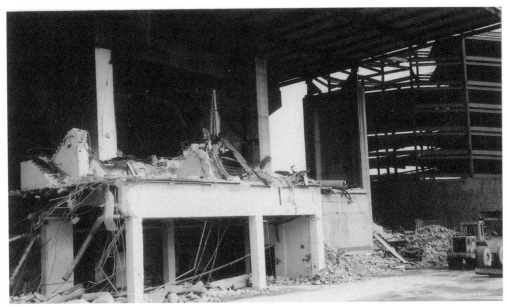

MANUAL DEMOLITION OF THE COLISEUM. Conventional demolition of the New Haven Veterans Memorial Coliseum began in October 2005. The main arena would be systematically removed, along with the box office area and portions of the overhead parking garage. This would all be completed before the remaining areas would be wired for implosion. It would be 15 months before the coliseum would actually be imploded.

COLISEUM'S FINAL MOMENT. As the final countdown to implosion began, the years of rumors became reality. The years of memories and hard work to try to save this building flashed before the eyes of coliseum supporters in seconds. Nothing could save the coliseum now, not even the ill-fated Connecticut Historical Buildings and Places application. The end was near, and implosion was imminent.

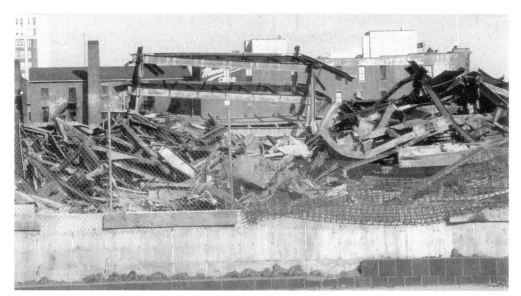

SURRENDER, JANUARY 20, 2007, I–DAY. As far as the coauthors are concerned, this was a very surreal experience. On this frigid Saturday morning, what remained of the coliseum, basically most of the overhead parking garage, was imploded. The ambulance chasers were out in full force as estimates placed between 10,000 and 20,000 people on hand to witness the final show. The authors left this charade feeling empty and disgusted.

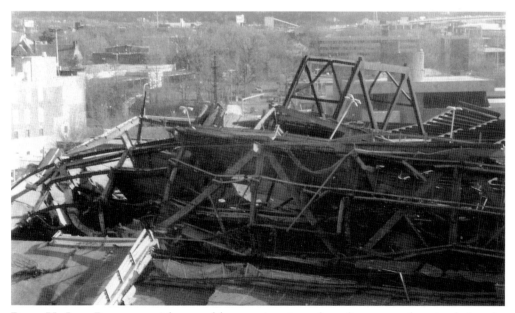

PILED UP LIKE PANCAKES. After one false warning siren, the coliseum was detonated after the second siren. All of the parking garage was now on ground level and would be easy pickings for the cleanup crew. The hockey memories and general coliseum memories in people's hearts will always be stacked taller than the pile of rubble from the implosion of the New Haven Veterans Memorial Coliseum.